C90 2076675

D0236917

With thanks to my father Steve, Malcolm, and all the teachers who let me draw when I wasn't supposed to...

First published in the United Kingdom in 2016 by
Portico
1 Gower Street
London
WC1E 6HD

An imprint of Pavilion Books Company Ltd

Copyright © Pavilion Books Company Ltd 2016
Images copyright © Guy Field 2016

All rights reserved. No part of this publication may be copied,
displayed, extracted, reproduced, utilised, stored in a retrieval system
or transmitted in any form or by any means, electronic, mechanical
or otherwise including but not limited to photocopying, recording,
or scanning without the prior written permission of the publishers.

ISBN 978-1-91023-285-9

A CIP catalogue record for this book is available from the British Library.

10 9 8 7 6 5 4 3 2 1

Reproduction by Mission Productions Ltd, Hong Kong
Printed and bound by Leo Paper Products Ltd.

This book can be ordered direct from the publisher at www.pavilionbooks.com

THE POWER OF THE PENCIL

DRAW • SKETCH • DOODLE • PLAY WITH A PENCIL

Guy Field

PORTICO

Contents

This Is the Power of the Pencil 6
The Story of the Pencil 8
Pencil Types 10
Even More Pencils! 12
Pencil Facts #1 14
How to Draw the Human Body 16
How to Draw a Selfie 18
How to Draw Hands 20
Exquisite Corpse and Hangman 22
How a Pencil Is Made 24
Say Hello to Leonardo da Vinci 26
Get a Grip! How to Hold a Pencil 28
How to Draw Superhero Lettering 30
How to Draw 3D Shapes 32
Whose Line Is It Anyway? #1 34
Shading for Light and Dark 36
Shading Techniques 38

Say Hello to Pablo Picasso 40
Abstraction to Cartoon 42
How to Draw with a Grid 44
Perspective and Movement 46
Drawing in Lines 48
Say Hello to David Shrigley 50
How to Draw Hair 52
Pencil Facts #2 54
How to Draw a Cartoon Skull 56
How to Draw Food 57
Drawing Styles 58
Lettering and Type 60
Even More Letters 62
How to Draw Scrolls and Flags 64
How to Add Colour 66
Battleships and Sprouts 70

Say Hello to Keith Haring 72
Drawing Jokes 74
How to Keep a Sketchbook 76
The Science of Doodling 78
The Super S 80
Kilroy 81
How to Draw a Dog 82
How to Draw a Cat 84
Lineography 86
Pencil Tools 90
How to Spin a Pencil Around
Your Thumb 92
Animate Your Own Flipbook 94
How to Draw a Comic Strip 96
Say Hello to Quentin Blake 98
Pencil Hacks 100

Avoid Common Drawing
Mistakes 104
Say Hello to Saul Steinberg 106
Whose Line Is It Anyway? #2 108
How to Draw a Car 110
How to Draw a Bike 112
Charlie Charlie and
the Scribble Game 114
Pencil Facts #3 116
Toilet Wall Doodles 118
Say Hello to Dr Seuss 120
How to Draw a Still Life 122
How to Draw Pizzas
and Mandalas 124
Say Hello to Jack Kirby 126

This Is the Power of the Pencil

As many of the world's greatest artists have said, 'Everything begins with a pencil.' It's true. With a pencil, the world is in your hands. You can turn a line into a circle, a circle into a sphere, and from there... you can go anywhere. So, pencil at the ready, it's time to make your mark on the world...

When one of the world's most revered geniuses, Leonardo da Vinci, wanted to make a better *everything* for the world, he started with a simple drawing. A sketch that would show him, and therefore us, the imaginable possibilities of the unimaginable; all he needed was his pencil and a piece of paper. In the famous film *Mary Poppins*, when the magical nanny proved that anything is possible, what did she do? She jumped feet-first into Bert's colour sketch and disappeared into a world of make-believe. If that wasn't the greatest way to show the potential magic that lies at the tip of a pencil, then I don't know what is. From drawing a still life to replicating an old photo, digitally enhancing a sketch on an iPhone app, or drawing a new character for your comic strip, everything begins with a pencil.

After that, all you need is your imagination.

A person with a certain proclivity towards pencils is called a 'lead head'.

'DRAWING MAKES YOU SEE THINGS CLEARER, AND CLEARER AND CLEARER STILL, UNTIL YOUR EYES ACHE.'

David Hockney

The drawings in this book were drawn with a Lyra Super Ferby Graphite HB pencil, in case you were wondering!

The Power of the Pencil is your first step into a world where anything is possible. Where imagination and creativity shake hands and take a line for a walk together. From a simple doodle to the conception of the characters in the latest *Star Wars* movie, so much creativity starts with a tube of wood and a graphite rod masterfully combined to produce one of humankind's greatest inventions: the humble pencil. This fine writing and drawing instrument not only changed the way humans communicate with each other, but it has also helped us to express and articulate our feelings and emotions in a way our mouths have still to catch up with. A pencil has helped us to unlock the closed doors in our heads. Drawing basic lines, shapes, grids and textures, our fingers and our brains connect to form intricate objects and patterns. These patterns can have geometrical significance, perspective and form. From the hyperrealistic pencil drawings of Diego Fazio to the simplest abstract cartoons of David Shrigley, these collections of shapes and lines can speak and communicate with us all. The pencil has enabled us to capture, record and condense our feelings in immeasurable ways, from poetic verse to saucy sketches. It helps us make our friends laugh, cry and think, and has reminded us (on more than one occasion) to not forget to buy milk and eggs. In the 21st century, the pencil has inspired technical innovations that have shaped every facet of our culture, from fashion to film, and from design to technology. This might all sound very highfalutin – 'It's just a pencil', some might say. And they're right. It is just a pencil. One of trillions that have been produced in the past few centuries. And that's the most magical part of all. A pencil is an object so un-unique, so mass-produced, so simple, so replaceable, so disposable and yet – our lives would mean so much less without it.

The Story of the Pencil

The pencil is one of the oldest and most widely used writing utensils in human history. It must be the one innovation that is on a par with the wheel and manipulation of fire in our evolution. This simple tool originated in prehistoric times, when chalky rocks and newly burnt sticks were used to draw on surfaces such as animal hides and cave walls, but it was not until the late 1400s that the earliest ancestor of today's pencil was developed.

The history of the pencil as a writing or drawing instrument is in fact the history of civilisation itself.

Around 1560, Italians Simonio and Lyndiana Bernacotti made blueprints for the modern, wood-encased carpentry pencil. Their light-bulb moment came when they hollowed out a stick of juniper wood and inserted a rod of graphite.

The first examples of pencil handwriting are from Greece. A scholar, Cadmus, is believed to have invented the letter – words sent as messages from one person to another on early forms of paper.

In 1564, large and pure deposits of solid lump graphite were found in Borrowdale, near Keswick, England. Graphite mining became a huge industry, though predominantly for manufacturing cannonballs!

Graphite is one of the softest solids, and one of the best lubricants because its carbon atoms form rings that can slide easily over one another.

At the time of the discovery at Borrowdale, graphite was believed to be a form of lead and was called 'plumbago' or 'black lead', but pencils have never used lead.

Graphite was first discovered in Europe, somewhere in Bavaria, at the start of the 1600s, although historians believe the Aztecs had used it for leaving 'marks' many hundreds of years before that.

The hexagonal pencil was developed by Lothar von Faber in the 1840s. It was the end of an era — pencils no longer rolled off tables.

GOOD POINT!

Graphite is one of the three natural forms of pure carbon – the others are coal and diamond.

The word *graphite* was coined in 1789 from the Greek word *graphein*, meaning 'to write'. 'Pencil' is derived from the Latin *pencillus*, meaning 'little tail', to describe the small ink brushes used for writing in the Middle Ages.

In 2015, Apple 'invented' the Apple Pencil. It has pressure-sensitive technology: pressing lightly will produce a thin stroke, while pressing harder makes a heavier, darker stroke. Steve Jobs once described pen-style devices as 'yuck' and something 'nobody would want'.

The first pencil factory, the Cumberland Pencil Company, opened its doors in 1832. In the 19th century, Cumberland pencils were regarded as the best because the high-quality graphite shed no dust and marked paper very cleanly.

The modern pencil was invented in 1795 by Frenchman Nicolas-Jacques Conté, a scientist serving in the army of Napoleon Bonaparte.

Pencil Types

Like humans, pencils can come in all shapes and sizes. Some are long and thin, some are short and fat, some are different colours, and others come in different packaging. But no matter what they look like on the outside, it's what is on the inside that counts. Let's take a look at the most common pencil types...

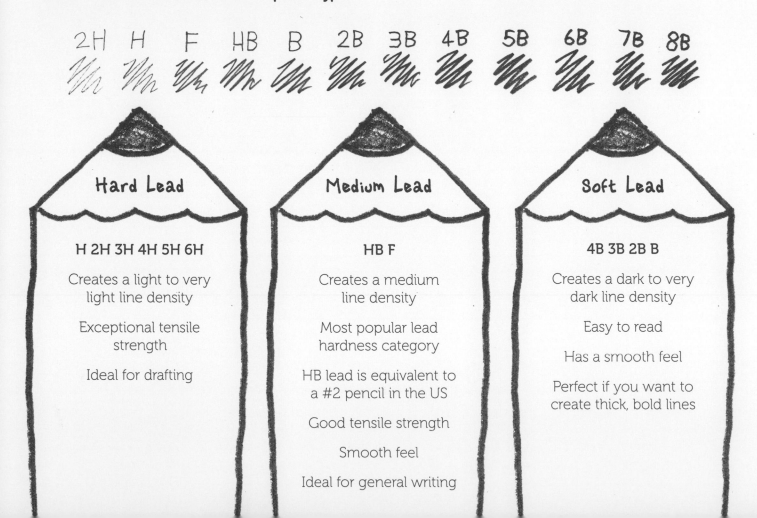

2H H F HB B 2B 3B 4B 5B 6B 7B 8B

Hard Lead

H 2H 3H 4H 5H 6H

Creates a light to very light line density

Exceptional tensile strength

Ideal for drafting

Medium Lead

HB F

Creates a medium line density

Most popular lead hardness category

HB lead is equivalent to a #2 pencil in the US

Good tensile strength

Smooth feel

Ideal for general writing

Soft Lead

4B 3B 2B B

Creates a dark to very dark line density

Easy to read

Has a smooth feel

Perfect if you want to create thick, bold lines

Conté Process

Early pencils were made using pieces of raw graphite dug straight from the earth, which were then shaped or cut into rods. The hardness or softness of pencils is always dependent on the quality (or purity) of the graphite, which is very difficult to control. It was not until 1795 that Nicolas-Jacques Conté developed a process for making pencil leads that is still in use today. The Conté process, as it is known, involves mixing finely powdered graphite with clay particles, shaping the mixture into a long cylinder and then firing it in a kiln. By controlling the ratio of clay to graphite in this way, varying degrees of hardness of graphite can be made, giving artists a larger range of pencil types to choose from.

ERASING HISTORY

On 30 March 1858, inventor Hymen Lipman received the patent for placing a rubber on the end of a pencil, a design he sold to Joseph Reckendorfer in 1862 for $100,000. Reckendorfer sued the world's largest pencil manufacturer, Faber-Castell, for copying the design. But in 1875 the US Supreme Court declared the patent invalid and Faber-Castell were able to continue making their pencil-rubbers.

USA v UK

Amazingly, there is still no ultimate global unifying system for pencil hardness classification. The Americans and British still have two different classification systems. If you want to convert US to British pencil types, this table will help:

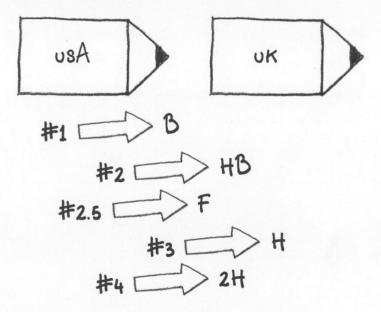

USA	UK
#1	B
#2	HB
#2.5	F
#3	H
#4	2H

The system in which these pencils are measured is known as the HB system. Pencils with an H lead are hard and will produce light lines. Pencils with B lead, on the other hand, are soft and produce darker lines. There's a range between the two, from 8B (the softest) to 6H (the hardest). An HB lead is located right in the middle of the spectrum and is also known as an ordinary #2 pencil.

Even More Pencils!

Charcoal pencil
Made of charcoal, this provides a darker black tone than a graphite pencil. Smudges easily.

Watercolour pencil
For use with watercolour techniques.

Graphite pencil
The most common type of pencil; varies from light grey to black. Made from a compound of clay and graphite, which is encased in wood.

Solid graphite pencil or woodless pencil
Used primarily in art that involves covering large spaces.

Carbon pencil
Produces a fuller black than graphite pencils, but is smoother than charcoal.

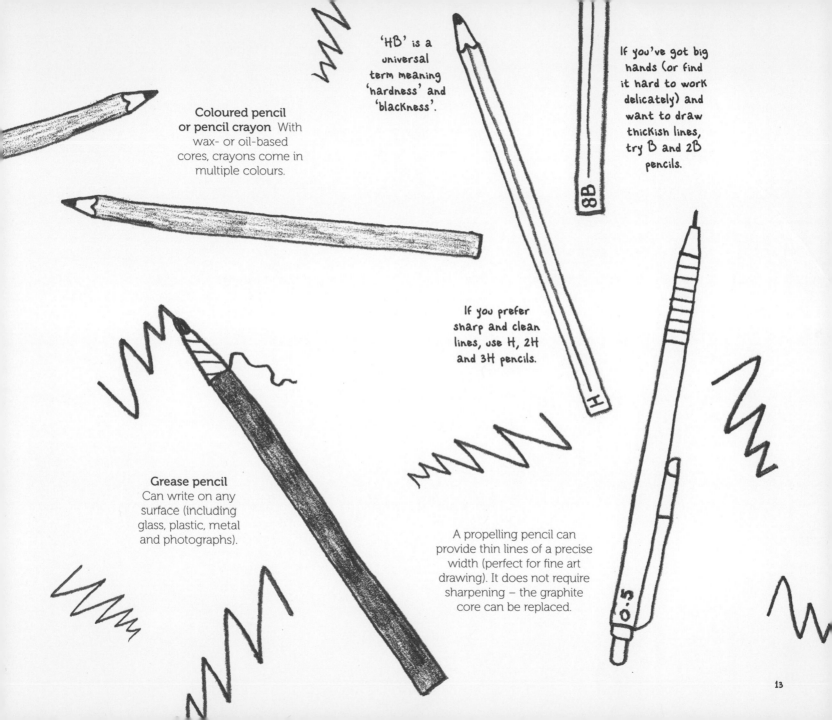

'HB' is a universal term meaning 'hardness' and 'blackness'.

Coloured pencil or pencil crayon With wax- or oil-based cores, crayons come in multiple colours.

If you've got big hands (or find it hard to work delicately) and want to draw thickish lines, try B and 2B pencils.

If you prefer sharp and clean lines, use H, 2H and 3H pencils.

Grease pencil Can write on any surface (including glass, plastic, metal and photographs).

A propelling pencil can provide thin lines of a precise width (perfect for fine art drawing). It does not require sharpening – the graphite core can be replaced.

13

Pencil Facts #1

The history of pencils is the history of civilisation itself. But it isn't just their history and their ability to make our imagination come alive that make pencils so fascinating. If you absolutely need to know everything about pencils — look no further.

More than half of all pencils in the world are manufactured in China. In 2004, Chinese factories produced 10 billion pencils, enough to circle the Earth more than 40 times!

The most expensive sketch on paper ever sold at auction is Raphael's *Head of a Muse*, a black chalk drawing. It sold at auction in 2009 for a whopping $47,941,095. Not bad for a ten-minute sketch!

Silverpoint drawings are the earliest known pencil drawings. They were created by using a thin rod of lead for scribing fine lines, hence the term 'lead pencil'.

Pencil marks are made when tiny graphite flecks stick to the fibres that make up paper. These fibres are often just fractions of a centimetre wide.

The ancient Egyptians, Greeks and Romans used a small lead disc for ruling guide lines on papyrus scrolls to help keep the lettering even. The Romans called it a *plumbum* – Latin for 'lead'.

In 2015, about 15–20 billion pencils were made worldwide (about 3.5 billion of these in the US). To make 15 billion pencils, you need to cut down 60,000 trees. It is believed that one hectare of trees (an area equal to a 'block' in US cities) can produce 3,500,000 pencils!

Astronomers have discovered 'Lucy', a star in the sky that is a chunk of crystallised carbon — effectively a diamond star of 10 billion trillion trillion carats, 4,000 Km in diameter and almost 50 light years from the Earth.

How to Draw the Human Body

The human body can be seen as a collection of cylinders, spheres and cones. With that in mind, turn your stick figures into fully fleshed bodies. Here's how!

Before you begin, think of the human body as a stick figure, or skeleton. This is known as the wire frame. You draw the bones first, then add the meat. Let's begin by drawing a man.

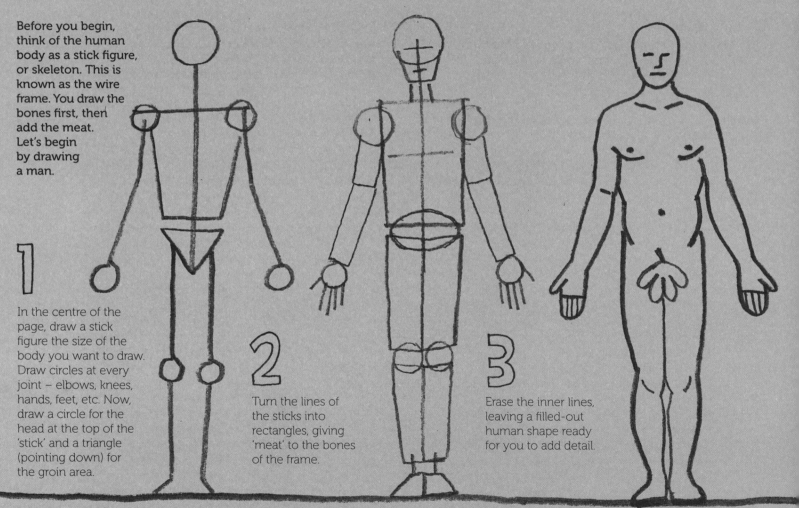

1 In the centre of the page, draw a stick figure the size of the body you want to draw. Draw circles at every joint – elbows, knees, hands, feet, etc. Now, draw a circle for the head at the top of the 'stick' and a triangle (pointing down) for the groin area.

2 Turn the lines of the sticks into rectangles, giving 'meat' to the bones of the frame.

3 Erase the inner lines, leaving a filled-out human shape ready for you to add detail.

PROPORTION, PROPORTION, PROPORTION

Once you have worked out the size of the head you want to draw (and therefore the size of the entire body), proportionally everything else should follow naturally... Just remember these 11 useful facts:

a The average male body is seven and a half heads high.

b It's about one head from the bottom of the chin to the bottom of the pectorals.

c From the top of the shoulder to the elbow, the bicep is about one and a half heads long.

d The arm, from armpit to fingertip, is about two-thirds the length of the leg from groin to sole.

e From navel to groin is about one head length.

f From chin to groin is about three heads.

g The neck is about one quarter of a head tall.

h The chest, from collarbone to top of the hip, is a little less than two heads.

i From elbow to wrist is about the same as from elbow to armpit. The thigh is about one and a half heads long.

J The shin is about two heads long.

K From the groin, the legs are about three and a half heads long.

THINGS TO REMEMBER

The size of the head is generally five eyes wide. There is one eye's distance between the two eyes.

IN ART THERE ARE TWO WAYS OF DRAWING A PERSON

1. A drawing of the head and face is known as a portrait.
2. A drawing of a person's whole body is called a figure drawing.

How to Draw a Selfie

Drawing a self-portrait, or a portrait of a friend, is one of the most difficult things to learn (and teach) in art. Don't worry if you don't get it right first time: always consider your drawings as works in progress that get better with each new sketch.

To start, let's grab a light pencil type. We don't want our first marks to be too dark. Keep it light until it's right! Let's start with the head. So, find a mirror, or choose something that reflects well enough to give you good detail, and something that is big enough to see your entire face without having to change angle or move. Even the front-facing camera on your phone should do the job.

1

Draw the shape of your head as you see it. Forget about your hair, no matter how cool it may be. You should draw an oval or roundish shape.

2

In the middle of this shape, halfway between the top of the head and the chin, draw a horizontal line very lightly. This is where your eyes will go. Your ears will also be placed over this line.

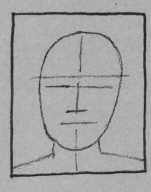

3

Now, again very lightly, draw a vertical line down the centre of the head, creating a cross-hair target. This will help keep your facial features symmetrical.

4

Halfway on the line from the eyes to the chin, draw a short horizontal line – very lightly. This will be where you place the bottom of the nose. Be sure it is perpendicular to the vertical line, otherwise your face will start to look wonky.

5

Just above the halfway point between the nose and the chin, draw a horizontal line for the mouth. Check it's perpendicular to the vertical line.

6

Now it's time for the eyes. Draw two curves on the line. A good way to judge spacing between the two curves is to leave a space of one curve between them.

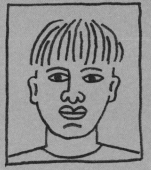

9

Now the mouth. Big mouth or small mouth? Use the line in step 5 as the mark between the upper and lower lip. For the nose and mouth, make sure they are lined up with the centre line going down the middle of the face.

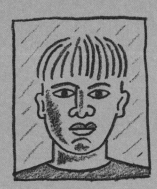

7

Look at your face carefully. What type of eyes do you have? And how do you want to represent them? Drawing your eyes, or a friend's, requires careful study of eye shape. Use the curves drawn in step 6 as the tops of the eyes. Draw lightly at first, and then darken it once you are impressed with your work.

8

Next comes your nose. Be honest: what type of nose do you have? Big, small, long, snub? Noses come in all shapes and sizes, but make sure you use the line from step 4 as the bottom of your nose.

10

The rest of the head. Very lightly, add the features that make you so good to look at. When drawing the hair, make sure it goes above and below the horizontal line from step 2. Erase any lines no longer required.

There are loads of apps that can do this for you these days, but why not integrate your drawings with your own photos, like this. It's a great way to combine photography with pencil art to create a unique image.

How to Draw Hands

Don't be fooled: drawing hands isn't as easy as you think. In fact, of all the body parts you can think of, hands are considered to be the hardest to master. Get them wrong, and they stand out and look weird. Get them right, and you deserve a double thumbs up.

1

Firstly, look at your hand. Observe it. Get to know it like the back of your hand, as the expression goes.

2

Now, draw the arm and wrist as a cylinder. This is your base, from which the hand grows.

3

Now, start drawing the hand by sketching a rounded square.

4

For the fingers, draw sausage-shaped cylinders sprouting from the base of the hand.

5

For the thumb, draw three overlapping oval shapes, decreasing in size the further away from the base they are.

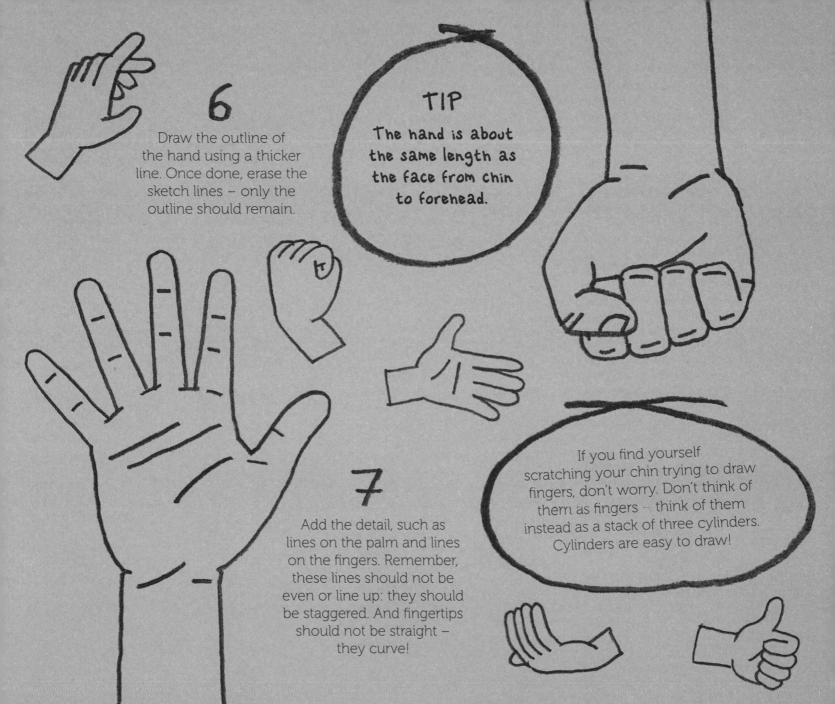

6

Draw the outline of the hand using a thicker line. Once done, erase the sketch lines – only the outline should remain.

TIP

The hand is about the same length as the face from chin to forehead.

7

Add the detail, such as lines on the palm and lines on the fingers. Remember, these lines should not be even or line up: they should be staggered. And fingertips should not be straight – they curve!

If you find yourself scratching your chin trying to draw fingers, don't worry. Don't think of them as fingers – think of them instead as a stack of three cylinders. Cylinders are easy to draw!

Exquisite Corpse

Let us turn our attention now to two of the most famous, and bizarre, pencil-and-paper games ever devised for children. Every child knows how to play and every adult sort of remembers how to play, but is a bit sketchy about the rules. Let's refresh our memories...

Exquisite Corpse

Invented during the Parisian surrealist movement of the 1920s, Exquisite Corpse is a great way of creating creatures, monsters and figures of the most surreal kind. It is best played by four people, each of whom takes a turn before passing on their wacky drawing.

Player One draws
the head and shoulders
FOLD OVER

Player Two draws
the shoulders to waist
FOLD OVER

Player Three draws
the waist to feet
FOLD OVER

Hangman

The most beloved of all drawing games, Hangman is a pencil-and-paper guessing game for two players, which is believed to have been invented during Victorian times, around 1894, but no one is entirely sure of its precise origin. The rules are simple. Player One thinks of a word, phrase, film title or sentence. It's Player Two's job to guess the word by suggesting letters or numbers within a certain number of guesses.

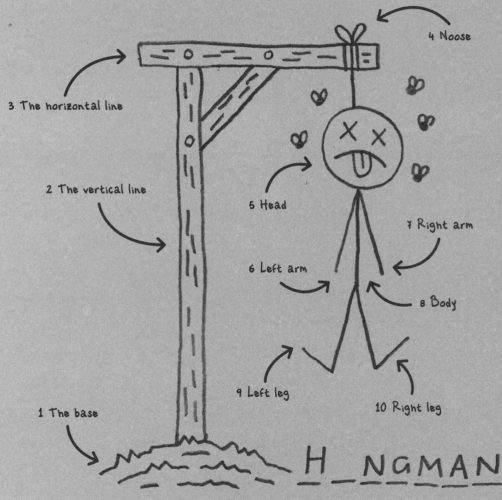

4 Noose

3 The horizontal line

2 The vertical line

5 Head

6 Left arm

7 Right arm

8 Body

9 Left leg

10 Right leg

1 The base

H_NGMAN

There are a few strategies you can deploy to win Hangman, if you're really desperate to win. Just remember that in the English language, the 12 most commonly occurring letters are, in descending order, e-t-a-o-i-n-s-h-r-d-l-u. Eliminate these first and you'll be victorious!

GOOD POINT!

1 Player One thinks of the word or phrase and becomes the 'executioner' – it's Player Two's job to guess it.

2 Player One draws a blank line for each letter in the word. For example, if they choose the word 'dragon', they would draw six blanks, one for each letter.

3 Player Two starts guessing letters they think might appear in Player One's word. If they are successful, Player One fills in the letter in the right place in the blanks. If they aren't successful, player One starts drawing the gallows and the hanged man, one bit for every wrong letter, in the order shown on the diagram.

4 If Player Two guesses the word, they win. If Player One draws the entire hangman without Player Two guessing the word, they win. And that's it!

How a Pencil Is Made

There's no point becoming best friends with a pencil if you're never going to learn where it comes from. You might know that it's made of wood and 'lead', but what else do you know? Although a pencil's design is very simple, most people have little idea of how pencils are actually made, and the process is pretty fascinating.

Pencil Mightier Than the Sword

 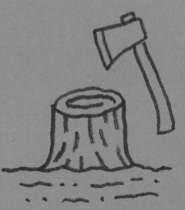 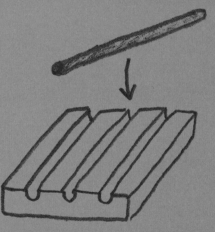

1 When incense cedar trees (the most popular type of tree used in pencil production) reach 14 years of age, they are mature enough to be cut and used for pencils. Once the trees have been felled and logged, they are cut into blocks about 19cm long – the average length of a pencil.

2 This block of wood is sliced into thin 'slats', which are then treated to make the wood dry and soft. This will help make the pencils easier to sharpen in the future.

3 After resting for 60 days, the slats are ready to be made into pencils.

4 Nine parallel grooves are carved into each slat to fit the 'lead' or graphite rod.

5 Now, a special type of glue is squeezed into the grooves to keep the graphite in place.

6 Before insertion into the slats, the pencil leads are put into an oven and heated to 980°C. The intense heat makes the leads smooth and hard, which results in good writing tips!

7 The graphite rods are squished into the slat on top of the glue.

Do you know what the metal thing at the end of your pencil is called? Have a guess.*

*Answer: the metal band at the end of your pencil that keeps the rubber in place is called a 'ferrule'.

8 A new slat is placed over the top of the first slat, sandwiching the graphite in the middle. This sandwich is heated and pressed hard, turning the two slats into one piece.

9 The sandwich is cut to produce individual pencils. A standard pencil diameter is 7mm.

10 The pencils are painted (between five and eight times!), varnished, sharpened and stamped.

How Graphite Is Made

Chunks of graphite (a soft, dark mineral) and clay are placed inside a huge rotating drum. Large rocks inside the drum crush the graphite and clay into a fine powder. Then water is added, and the mixture is blended in the drum for up to three days.

A machine squeezes all the water out of the mixture, leaving behind a grey sludge.

Huge wheels grind the dried sludge into a fine powder, and water is blended in to make a soft paste.

The paste is pushed through a metal tube and comes out in the shape of thin rods. The rods are cut into pencil-length pieces, called leads, and sent along a conveyor belt to dry.

Remember

A pencil lead's hardness is determined by the ratio of graphite to clay. The greater the graphite content, the softer and blacker the lead. The greater the clay content, the harder and less black the lead.

Say Hello to Leonardo da Vinci

There is more to this Renaissance man than the *Mona Lisa* and *The Last Supper*. Leonardo da Vinci was a creative visionary whose giant leaps in imagination advanced and influenced human endeavours for centuries to follow. But all of it, everything da Vinci ever devised, started with a sketch...

L. da Vinci

10 Things to Know About Leo

1 Da Vinci lived during the Renaissance era (1300–1700), a cultural movement that led to significant and important developments in art and science.

2 Da Vinci's thousands of sketches and drawings highlight his imagination and curiosity across all aspects of life. He studied plants and flowers, musical instruments, calculators, the flight of birds, the movement of water, horse mechanics and human anatomy, as well as making sketches for paintings.

3 Many of da Vinci's concepts came to life – he drew the first blueprints for helicopters, hang gliders, bridge architecture and even shoes for walking on water!

4 Despite making only about a dozen paintings, da Vinci is best known as a painter. However, he was prolific as a sketcher – there are over 13,000 pages of notations, sketches and finished drawings throughout his famous Codex journals.

5 Da Vinci's skill as a great draughtsman became a useful tool for him not only as an artist, but also as a scientist, anatomist and inventor.

6 As a draughtsman, da Vinci is believed to have invented *curved* hatching, a technique that helps to give objects an effective three-dimensional look.

'DRAWING IS BASED UPON PERSPECTIVE, WHICH IS NOTHING ELSE THAN A THOROUGH KNOWLEDGE OF THE FUNCTION OF THE EYE.'

Leonardo da Vinci

7 As a young man, da Vinci sketched with metal pencils on tinted paper. As he grew older, he preferred to draw with coloured chalk.

8 Leonardo played close attention to light and shadow in his work. He employed a 'sanguine' style (using a chalk or crayon in a blood-red, reddish or flesh colour) to master the art of shading and light. If you have ever wondered why the *Mona Lisa* is called the greatest painting in the world, it is because of da Vinci's incredibly nuanced shading, which brings to life that mysterious smile of hers.

9 Practice makes perfect. Leonardo's sketchbooks were full of drawings of noses and other body parts, with little variation between each sketch. As it turned out, da Vinci was amassing a collection of drawings so that he could mix and match as needed when he came to paint large commissions.

10 *The Vitruvian Man* (1490-ish) is Leonardo da Vinci's most famous drawing. Sketched with pen and ink, it represents the perfect geometrical proportions of the human being, based on the early writings of the Roman architect Vitruvius.

GOOD POINT!

In 1994 Microsoft founder Bill Gates purchased Leonardo da Vinci's most famous scientific writings, the *Codex Leicester* when up for auction. The codex contains explanations of water movement, fossils and the moon, among other things. It was bought for $30 million.

Get a Grip!
How to Hold a Pencil

There are many myths about how an artist should hold a pencil and why. Do what feels right for you and feel free to experiment, but before you settle on a grip, why not learn about the three most common ways of holding a pencil?

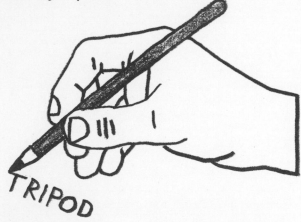

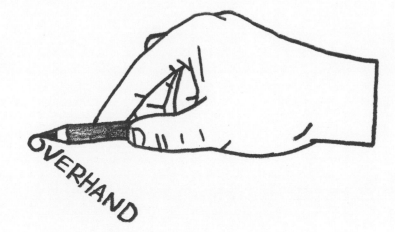

THE TRIPOD GRIP

The tripod grip is the most common way to hold a pencil for writing. Place your thumb and forefinger around the pencil to form a triangle with the middle finger, which is supported by the ring and little fingers. The upright position of the pencil allows the tip, rather than the side of the pencil, to be used. For the extended tripod grip, move the tripod grip further up the pencil. This is good for sketching as it allows more freedom and prevents smudging.

THE OVERHAND GRIP

This grip is the one most often recommended for sketching, as it allows you to shade with the side of the pencil to add more value to a drawing. To perfect the overhand grip, brace the pencil lightly against the fingers with the flat of the thumb. Your whole arm should help to make movements.

One of the worst things you can do is to force yourself into using a grip that feels unnatural, or one that upsets the natural flow of your line. Experiment – what feels right for you?

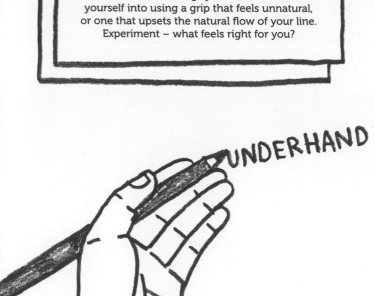

UNDERHAND

NO!

INCORRECT

THE UNDERHAND GRIP

The underhand pencil grip is a very loose and relaxed way of holding a pencil. It is basically a rotated tripod grip and is useful for broad sketching, such as with a charcoal pencil.

HOW NOT TO GRIP A PENCIL!

For best results, make sure you keep a relaxed grip on the pencil — a tight, vice-like grip is tiring and restricting.

How to Draw
Superhero Lettering

Drawing isn't all about shapes and lines. Lettering and typography are important. Comic book heroes are everywhere these days, so let's take a look at how to draw classic superhero lettering. If you think of any great superhero comic, from DC Comics' Superman and Batman to Marvel Comics' Iron Man, X Men, Hulk and Spiderman, they all have their own unique lettering and it is as famous as the characters themselves.

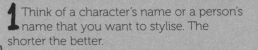

1 Think of a character's name or a person's name that you want to stylise. The shorter the better.

2 Draw a rectangular grid, creating rectangular blocks for each letter. The square blocks, and the gaps between each block, must be the same size – that way each letter appears equal.

3 Within the borders of the squares, block in the letters of your character or name.

4 Erase the border lines, leaving only the letters visible.

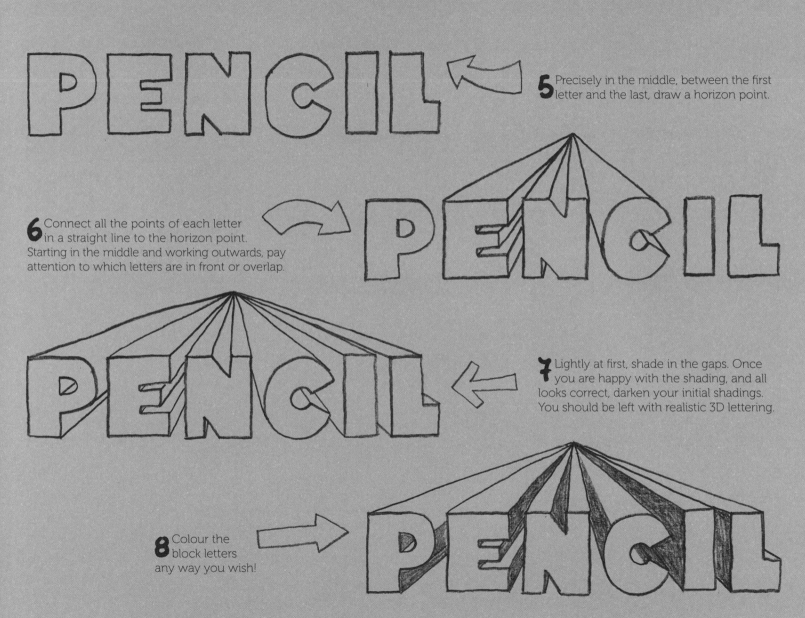

5 Precisely in the middle, between the first letter and the last, draw a horizon point.

6 Connect all the points of each letter in a straight line to the horizon point. Starting in the middle and working outwards, pay attention to which letters are in front or overlap.

7 Lightly at first, shade in the gaps. Once you are happy with the shading, and all looks correct, darken your initial shadings. You should be left with realistic 3D lettering.

8 Colour the block letters any way you wish!

31

How to Draw 3D Shapes

Drawing is all about shapes. If you can master shapes — which is simple — the only thing stopping you from becoming a master artist is your imagination. Whether you're drawing a human body, a tree, a bowl of fruit or a rocket ship, if you get your shapes right, you'll be in shipshape form to design a masterpiece.

Your task here is to master drawing five fundamental shapes – the circle, square, rectangle, hexagon, cone and triangle – in three dimensions, and use them to create your very own rocket ship.

'ALL ART IS BUT DIRTYING THE PAPER DELICATELY.'

John Ruskin, *The Elements of Drawing*

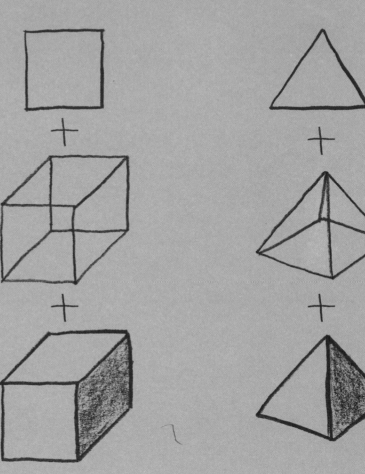

SQUARE + 3D = CUBE

1 Draw a regular square.
2 Draw another square (same proportions) behind the original square. Add table legs.
3 Rub out the inner lines.

TRIANGLE + 3D = PRISM

1 Draw an arrow. Make the arms slightly shorter than the centre line.
2 Connect the outer left and right lines to the centre line.

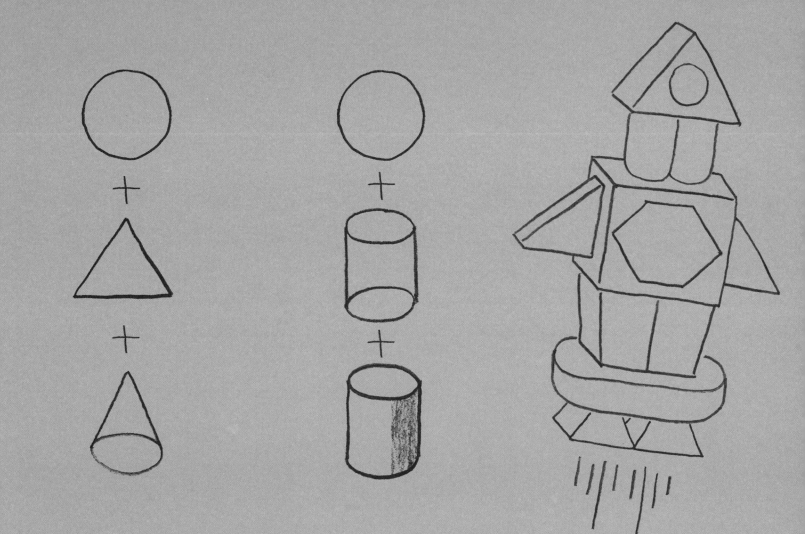

CIRCLE + TRIANGLE + 3D = CONE

1 Draw an oval shape.
2 Draw two lines connecting to each other at a central point above.

CIRCLE + 3D = CYLINDER

1 Draw an oval shape.
2 Add table legs to the oval shape.
3 Connect the bottom corners – with a smile!

Now we know how to draw three-dimensional shapes, we can add them all together to make one large image – a rocket ship. Try designing your own rocket, based on this drawing. Reconfigure the shapes to your own rocket design. Cones make excellent noses, and cylinders make perfect thrusters.

33

Whose Line Is It Anyway? #1

Many, if not all, of the world's greatest pencil users have at one point or another given poetic and helpful advice on the subject of drawing and what art means to them. If art is anything, it is standing on the shoulders of giants, and listening to what they have to say. Remember these lines — if you forget them, you do so at your peril!

'IN SPITE OF EVERYTHING I SHALL RISE AGAIN: I WILL TAKE UP MY PENCIL, WHICH I HAVE FORSAKEN IN MY GREAT DISCOURAGEMENT, AND I WILL GO ON WITH MY DRAWING.'

Vincent Van Gogh

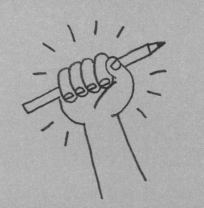

'A #2 PENCIL AND A DREAM CAN TAKE YOU ANYWHERE.'

J. A. Meyer

'HERE IS A PEN AND HERE IS A PENCIL, HERE'S A TYPEWRITER, HERE'S A STENCIL, HERE'S A LIST OF TODAY'S APPOINTMENTS, AND ALL THE FLIES IN ALL THE OINTMENTS, THE DAILY WOES THAT A MAN ENDURES — TAKE THEM, GEORGE, THEY'RE YOURS!'

Ogden Nash

'THE AVERAGE PENCIL IS SEVEN INCHES LONG, WITH JUST A HALF-INCH ERASER — IN CASE YOU THOUGHT OPTIMISM WAS DEAD.'

Robert Brault

TICK TOCK

'DRAWING TAKES TIME. A LINE HAS TIME IN IT.'

David Hockney

'I DESPERATELY NEEDED SOMETHING TO HOLD ON TO, SO I HELD ON TO MY PENCIL.'

Joann Sfar

'LYING IN BED WOULD BE AN ALTOGETHER PERFECT AND SUPREME EXPERIENCE IF ONLY ONE HAD A COLOURED PENCIL LONG ENOUGH TO DRAW ON THE CEILING.'

G. K. Chesterton

'IT'S NOT HOW BIG YOUR PENCIL IS; IT'S HOW YOU WRITE YOUR NAME.'

Dave Mustaine

'LIVES ARE LIKE RETRACTABLE PENCILS. IF YOU PUSH THEM TOO HARD THEY'RE GONNA BREAK.'

Flight of the Conchords : Pencils in the Wind

'DRAWING IS THE "BONES" OF ART. YOU HAVE TO BE ABLE TO WALK BEFORE YOU CAN RUN.'

Dion Archibald

'WHEN YOU WRITE DOWN YOUR IDEAS YOU AUTOMATICALLY FOCUS YOUR FULL ATTENTION ON THEM. FEW IF ANY OF US CAN WRITE ONE THOUGHT AND THINK ANOTHER AT THE SAME TIME. THUS A PENCIL AND PAPER MAKE EXCELLENT CONCENTRATION TOOLS.'

Michael Leboeuf

'LEARN TO DRAW. TRY TO MAKE YOUR HAND SO UNCONSCIOUSLY ADEPT THAT IT WILL PUT DOWN WHAT YOU FEEL WITHOUT YOUR HAVING TO THINK OF YOUR HANDS. THEN YOU CAN THINK OF THE THING BEFORE YOU.'

Sherwood Anderson

'I HAVE LEARNED THAT WHAT I HAVE NOT DRAWN, I HAVE NEVER REALLY SEEN.'

Frederick Franck

'IN DRAWING, NOTHING IS BETTER THAN THE FIRST ATTEMPT.'

Pablo Picasso

Shading for Light and Dark

It's time to dim the lights and talk about... shading. Light and shadows visually define the objects we see. Take a look around you; look at which objects are reflecting light (and how), and which objects are casting shadows. Before you can capture light and shadows in a drawing, you must first understand how they are related.

NEGATIVE SPACE

This is the space and forms seen around your subject. For example, if you are drawing a chair, it is the space between the chair legs.

Values Scale

Before you begin your drawing, devise a values scale. This will help you to determine the different depths of your shaded drawing.

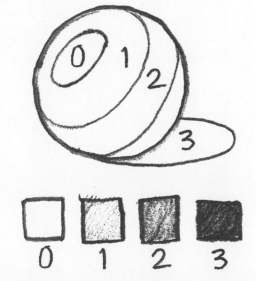

A values scale highlights the different shades of grey between white and black. Artists use these values to translate the light and shadows they see into *shading; it is this shading that creates the illusion of a third dimension.* To create a value scale, draw a circle (you can do this in the corner of your drawing). Break the circle into four grades of shading and draw squares for a key, numbering them 0 to 3. You can do more than four as you grow in your shading skills, but four shades in the scale gives you a place to start.

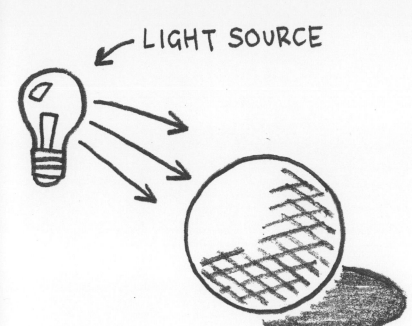

LIGHT SOURCE

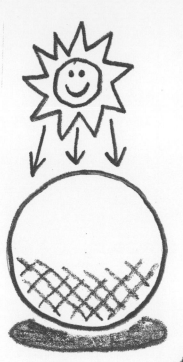

GOOD POINT!

Choose Your Pencil

For complex shading, it is necessary to use specialised artist's pencils for the best results. Use the softest pencil (2B–10B) you have available. This will allow you to blend it easily. A hard pencil (2H–10H) will be very difficult to shade with.

Light Source

Take a look at the model or object you are drawing. Take note of the direction from which the dominant light source originates. The direction the light is coming from and the way it falls on the object determine every aspect of a drawing.

Always shade away from your light source. The brightest (and therefore lightest) areas will be those closest to the light. The darkest areas will be the furthest away.

Observe any instances of glare or interesting reflections. These areas tend to be the brightest parts of a drawing.

The presence of a light source will always create shadows. It is the shaded depth of a shadow that creates a super-realistic drawing, so don't forget to shade these as well as the bright areas.

Leonardo da Vinci once wrote that light and shade should blend 'without lines or borders in the manner of smoke'. The poeticism of his description gave us the term *sfumato*. Da Vinci's use of soft shadows around the corners of the eyes and mouth, such as on the *Mona Lisa*, made faces appear more real.

Shading Techniques

Once you understand the position of light in your drawing, you can tackle the four fundamental techniques of shading: hatching and cross-hatching, scribbling, stumping and stippling.

Hatching

Hatching is making a series of short parallel marks. The marks can be made diagonally, horizontally or vertically, but they should all line up.

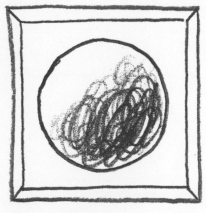

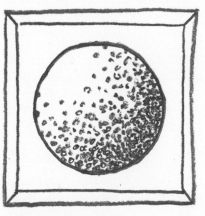

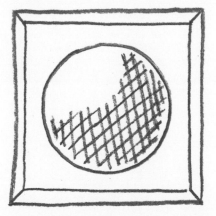

Scribbling

This one is self-explanatory. Add shade by scribbling dark lines loosely together. It's not very masterful, but it can be effective if drawing very quickly.

Stippling

Stippling is the creation of a pattern, using small dots, to highlight varying degrees of shading. The closer and more dense the dots, the darker the areas you create.

Cross-Hatching

This is a method of shading by drawing crossing lines that form many small 'X' shapes on your drawing. Cross-hatching is a useful technique for creating darkness quickly and easily, while simultaneously adding texture.

The master painter Rembrandt has many excellent examples of cross-hatching in his works, using line to create (or describe) a sense of three-dimensionality. Rembrandt also used cross-hatching to create a dramatic contrast between light and dark.

Commonly used for drawing skin textures, circulism consists of drawing lots of tiny overlapping circles. Press down lightly when using this technique; you can always go back over it if it's not the right shade when you're finished.

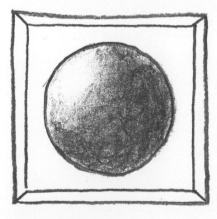

Choose Your Pencil

For complex shading, use specialised artist's pencils for the best results. Choose the softest pencil (2B–10B) you have available, as it will blend easily. A hard pencil (2H–10H) will be very difficult to shade with.

Stumping

A blending stump is used by artists to smudge pencil marks together. In order to stump your drawing, you need this drawing tool, which is made of soft paper that is tightly wound into a stick and sanded to a point at both ends.

JOIN THE DOTS

Once you've mastered the shading techniques on this page, why not try your hand at a technique called pointillism. This is a type of shading that is done with a series of tiny dots placed next to each other. It is very time-consuming but can produce some great results.

Say Hello to Pablo Picasso

One of the world's most admired and revered artists, Pablo Picasso needs little introduction. As of May 2015, his painting *Woman of Algiers* (Version O) is the most expensive painting ever bought — $179 million! Picasso's revolutionary artistic accomplishments helped to usher in a new, more daring approach to art, and his paintings and drawings will continue to influence new artists for many generations to come.

What Do We Know About Picasso?

1 Pablo Picasso's first word was *piz*, short for *lápiz*, the Spanish word for 'pencil'. Picasso was considered a child prodigy at art.

2 In 1909, Picasso co-founded (with French artist Georges Braque) the art movement known as cubism.

3 Picasso's *Guernica* is one of the most important paintings of the 20th century. Completed in 1937 as a response to the bombing of the Basque town of Guernica during the Spanish Civil War, the painting articulates the destructive reality of modern warfare. It is arguably Picasso's most famous work.

4 Throughout his career, Picasso became known for going through distinct colour phases, of which the Blue Period (1901–1904) and the Rose Period (1904–1906) are the most famous.

'IT TOOK ME 4 YEARS TO PAINT LIKE RAPHAEL, BUT A LIFETIME TO PAINT LIKE A CHILD.'

The Weeping Woman, completed in 1937, depicts Pablo's muse, Dora Maar.

Like Vincent Van Gogh, Picasso's prestigious predecessor in the self-portrait canon, Picasso loved to paint himself – he enjoyed fusing the external image of the man with the subjective projection of the artist.

picasso

One of Picasso's most famous paintings, *The Old Guitarist*, was completed in Madrid in 1903, and was inspired by the miseries inflicted on poor people.

Picasso's *Dove of Peace* was chosen as the emblem for the First International Peace Conference in Paris, 1949. This simple, graphic line drawing is one of the world's most recognisable symbols of peace.

Picasso's kidney-shaped palettes are now revered as a work of art in themselves, a symbol of the artist's mastery of colour. He said: 'Colours, like features, follow the changes of the emotions. Why do two colours, put one next to the other, sing?'

Abstraction to Cartoon

Comic book artists like Jack Kirby are famous for personifying superheroes in a realistic, human way. But, take that principal theory one stage further and you have abstraction — an art movement that simplifies all drawing down to its basics.

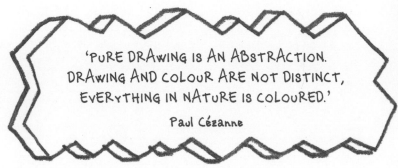

'PURE DRAWING IS AN ABSTRACTION. DRAWING AND COLOUR ARE NOT DISTINCT, EVERYTHING IN NATURE IS COLOURED.'

Paul Cézanne

Back to Basics

Abstraction (from the Latin *abs*, meaning 'away from', and *trahere*, meaning 'to draw') is the artistic process of taking a detailed object and removing its features in order to reduce it to a set of essential characteristics.

Let's look at a pineapple, for example.

When we abstract an image such as this pineapple and 'cartoonise' it, or simplify it, we don't eliminate the details: we merely focus on specific details. By stripping down an image to its essential 'meaning' in this way, an artist can amplify that meaning in a way that realistic art can't. This pineapple, when reduced to its bare characteristics, is nothing more than a circle with hair. If we reverse the idea, we can begin to understand what gives objects structure.

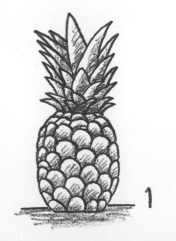

1

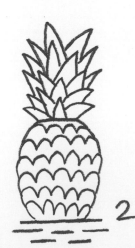

2

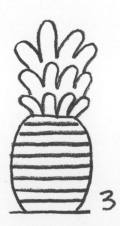

3

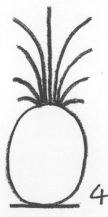

4

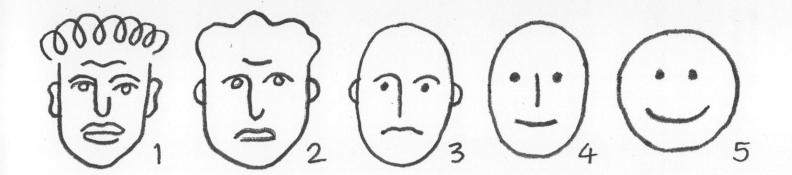

CARTOONISATION

For example, a face, when in abstraction, is nothing more than a circle with dots and lines. But when detail is added, it becomes much more complex. When we look at a realistic drawing of a face, we see it as the face of another human. But when we look at the face of a cartoon, we see ourselves. This is a fundamental theory of drawing.

Julian Opie

Julian Opie is one of the most influential and popular artists today. His semi-abstract style became famous when he designed the album cover for *Blur: The Best Of*. His highly stylised work saw the four band members' images reduced into figurative reproductions. The human face is characterised by black outlines with flat areas of colour, and minimalised detail, to the extent that an eye can become just the black circle of the pupil, and sometimes a head is represented by a circle with a space where the neck would be. In this way, Julian Opie tries to present the complexities of the human form by reducing it to its mere basics.

GOOD POINT!

Modern cartoon artists such as Cyanide & Happiness take Julian Opie's style one step further. They describe the human condition with stick-figure characters, where features such as eyes, hands and mouths are characterised by nothing more than dots and lines, yet we view them as alive.

How to Draw with a Grid

Using a grid is an effective way to transform and reproduce a drawing in your sketchbook and scale it up to a bigger work of art without having to worry about replicating it — the grid does all the work for you, while having the added benefit of improving your drawing and observational skills.

GOOD POINT!

The grid method has been used as a tool for creating correct proportions for thousands of years, and dates back to the ancient Egyptians. Even the great Leonardo da Vinci used it. It is a useful method for master and aspiring artists alike. Street artists such as Banksy also use the grid method to scale up their stencil artwork to the size required for a large wall.

Gridlocked

In a nutshell, replicating or scaling up your drawing with the grid method involves drawing a grid of either equal or increased scale to which you then copy the original, focusing on one square at a time, until the entire image has been duplicated.

Once you're finished, you simply erase the grid lines and start working on your increased-size drawing, which will be now be in perfect proportion!

1 Draw a grid of four squares over your drawing.

2 To make your drawing, in this instance a smiley face, larger — but retain the same proportions — focus on replicating one square at a time.

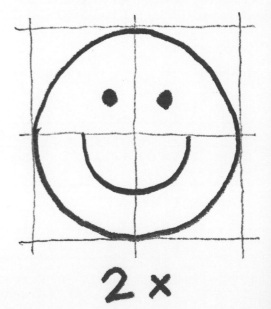

1x

2 x

3 Once you are finished with duplicating one square in the grid, move on to the next.

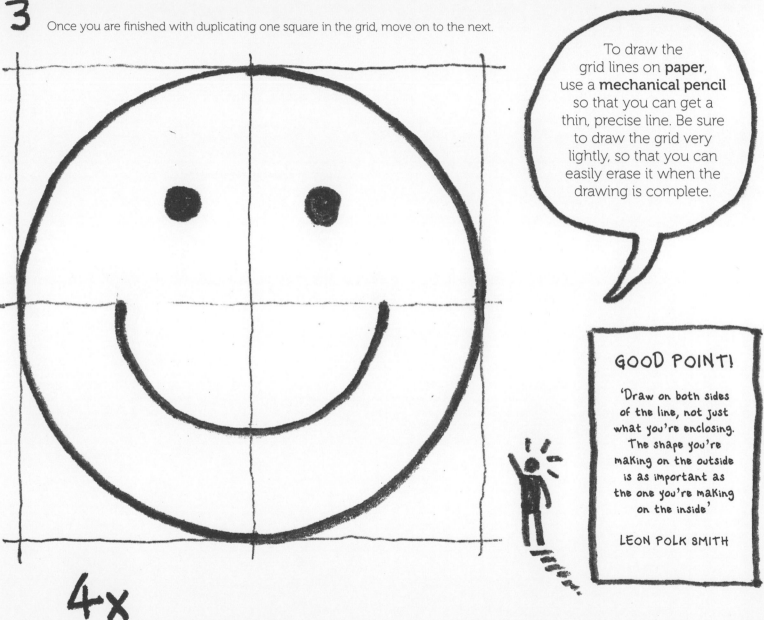

4x

To draw the grid lines on **paper**, use a **mechanical pencil** so that you can get a thin, precise line. Be sure to draw the grid very lightly, so that you can easily erase it when the drawing is complete.

GOOD POINT!

'Draw on both sides of the line, not just what you're enclosing. The shape you're making on the outside is as important as the one you're making on the inside'

LEON POLK SMITH

Perspective and Movement

Perspective and movement are two of the most important and fundamental principles to master in drawing. If you want to give your drawings that extra something, grab your pencil and take note now...

Types of Perspective

Linear Perspective
Conveys depth by reducing the size of objects as they regress into the background. For example, when you look at a house in the foreground and at one of the same type in the background, as far as your eyes are concerned they are different sizes!

Atmospheric Perspective
Creates an illusion of depth by blurring the lines and details of objects as the image fades into the distance. Your eyes can only see a certain distance before objects blur into one.

Colour Perspective
Conjures depth by blurring all the colours of a background into one or two primary colours.

Planar Perspective
The division of a drawing or painting into a series of layered planes to create a sense of depth.

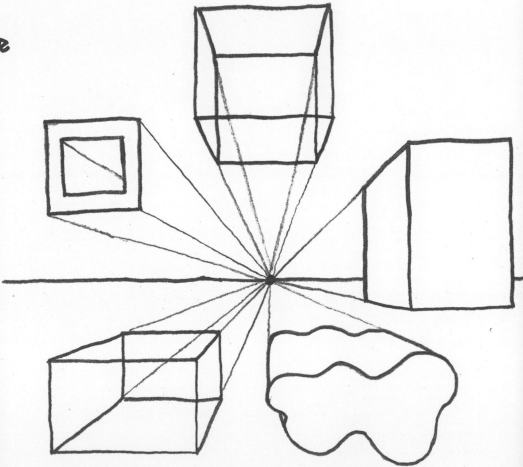

Perspective Drawing

This is a technique used to draw a three-dimensional scene on a two-dimensional surface. Perspective in drawings makes objects appear more realistic, as they appear to recede as they get further away from the foreground. If the receding lines are extended, they will meet at points called vanishing points.

To make a perspective drawing, follow this step-by-step guide:

1 Draw an object, such as a square.

2 Mark a vanishing point in the background. The vanishing point can be above or below the object, depending on the perspective you are going for.

3 Draw guide lines from each corner of the shape to the vanishing point.

4 Congratulations – you have established a sense of perspective!

Things to Remember

One-point perspective uses one vanishing point, and is used to draw room interiors. Two-point perspective uses two vanishing points, connected by a horizontal line. Two-point perspective is helpful when drawing in 3D, such as turning a square into a cube.

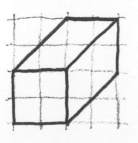
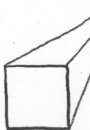
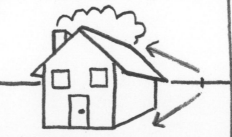

Movement Lines

Known as action lines or speed lines, movement lines are abstract lines that appear behind a moving object (such as a person, for example), drawn parallel to its direction of movement, to make it appear as if it is moving. Movement lines are used in art to indicate direction, force and speed. They feature very heavily in Japanese manga art.

Drawing in Lines

What is a line? Think about it. Geometrically, it connects two points together. It is a journey traced by a moving point, such as a pencil tip moving from one place to another. 'Drawing is a line taking a walk', as artist Paul Klee perfectly summed up. Next time you draw a line, revel in its creative majesty — because without it we wouldn't be able to get from A to B. Lines can be straight, short, long, thick, thin, smooth, textured, broken, flowing, erratic, dark, light, heavy, soft, hard, playful, smudged, uneven, crooked — their potential is limitless.

Types of Lines

There are two main types of lines – actual and expressive, which are divided into subcategories. Let's learn more about lines.

1 *Actual* lines are lines that are real – they exist in a physical sense. Examples of actual lines include lines painted on a motorway, tree branches, telegraph poles, and the words on this page.

2 *Contour* lines define the edges of objects, like the sides of this book, the edges of a door, or the roundness of a stone. Contour lines define the edges of an object but also the negative space between them, such as the empty space between a window's edges.

3 *Expressive* lines give emotional qualities to lines, which are then absorbed into the drawing. For example, lines with sharp, angular peaks – like a pulse monitor – impart a feeling of anger or aggression. By comparison, smooth lines without sharp edges make us feel calm and comfortable.

4 *Implied* lines are lines that we see in our mind's eye which fill in the spaces between objects, such as a line that goes from the eyes of one person to another in a romantic gaze.

5 *Geometric* lines are mathematically precise and straight. They have hard and sharp edges. Never found in nature, true geometric lines are only found in man-made constructions like buildings and utensils. Geometric lines convey a sense of order and conformity.

6 *Organic* lines are the types of lines found in nature. They are curved and often fluid. Think of a ripple of water in a pond, or a branch of a tree. These lines convey a sense of naturalness, spontaneity and relaxation.

7 *Descriptive* lines are found in areas such as handwriting, charts and diagrams. They give us information. They can also be used as decorative elements. Descriptive lines such as cross-hatching are used in two-dimensional work to suggest three-dimensionality.

Each type of line says something different and awakens a different emotion. An artist chooses a certain line for a certain purpose and to enhance their intentions.

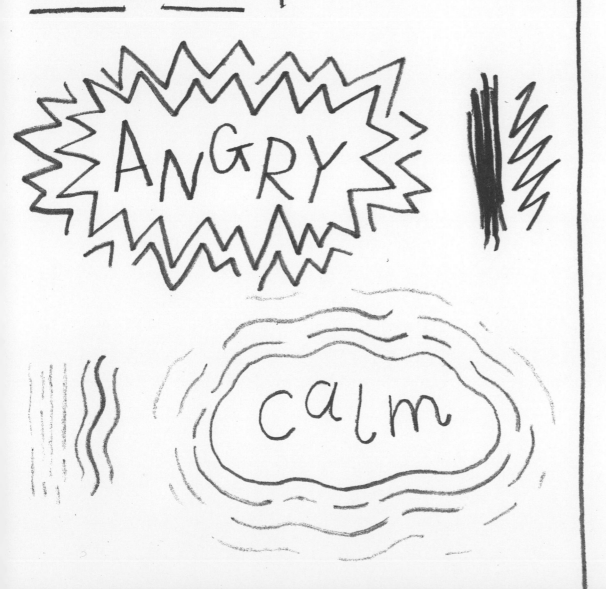

DRAWING A BATH

Draw a bath – not literally, but figuratively – in your mind. Think of the journey of the lines you create. How many lines do you need? Can you draw it in one fluid motion, or do you need to lift the pencil up? This is a great exercise to help you think more about lines and their importance in every drawing you ever do.

Say Hello to David Shrigley

Following a long history of surreal cartoonists, from Spike Milligan to Edward Lear, David Shrigley's work with a postmodern pencil has made him one of the most popular British artists of the past 20 years. While he produces sculptures, writes books and directs music videos, it is his drawings that have made his critics scratch their chins the most... and his fans laugh the loudest.

1 David Shrigley's simple, satirical and cartoon-esque drawings represent the everyday doubts and fears of the human condition. They are deliberately dysfunctional.

2 His drawings and handwritings highlight a world frustrated by everyday incompetence and boredom.

3 Shrigley's work focuses on the mundanity and the universal absurdity of modern life, where comedy and tragedy are just different takes on the same event.

4 Shrigley's style is awkward and is made up of messy scribbles complete with crossings-out and hand-drawn figures.

5 He has an utter disregard for the traditional techniques of drawing such as perspective, scale and movement.

6 Shrigley highlights the ridiculous and nonsensical aspects of the human condition, such as our futile attempts to make order out of chaos and our obsession with endless lists, rules and laws.

7 He never draws anything twice and so his work often features scribbled-out parts and misspelt words.

8 Words play an important role within, and throughout, his work. He is interested in how we interpret text and image together, especially when they are combined in witty ways or as juxtapositions.

'THE PAPER WEIGHS NOTHING BUT THE INK IS HEAVY.'

9 *Really Good*, his sculpture of a hand with its disproportionately large thumb in a 'thumbs up' position, was displayed on Trafalgar Square's fourth plinth in 2016.

10 Shrigley's most famous sculptural works include his use of taxidermy. For his piece *I'm Dead* (2010), a stuffed dog stands on its back legs and holds a sign saying it is dead!

12 According to Shrigley, 'There has to be humour in life, or else it's not life.'

14 Do Shrigley's drawings parody the absurd nature of modern conceptual art or are they the epitome of conceptual art? Nobody knows! What we do know is that Shrigley's art highlights the importance of humour within contemporary art and art criticism.

A simplistically rendered black and white line drawing of a pipe including the text 'This is nothing' is an ironic homage to René Magritte's famous painting *Ceci n'est pas une pipe* [This Is Not a Pipe].

11 Shrigley will create as many as 50 drawings in a single session. Can you?

13 Shrigley claims that, 'Drawing was a reaction to art school and the seriousness with which the artwork was treated.' Do you feel the same?

Works of Art
Check out David Shrigley's most famous works of art. Can you work out what they mean?

I'm Dead, 2010

Lost, 1996

The Bell, 2007

Ostrich, 2009

Gravestone, 2008

Unfinished Letter, 2003

How to Draw Hair

Like hands, eyes, noses and mouths, drawing lifelike hair is incredibly hard — unless you're aiming for an abstract cartoon. As the mantelpiece of our heads, hair has long been considered a symbol of human beauty and its portrayal can add motion and colour to a drawing and tell a story as important as facial expressions. From woolly curls to thick, wavy locks and the Greek goddess Medusa's snakes, hair takes many forms. Here's how to get it right...

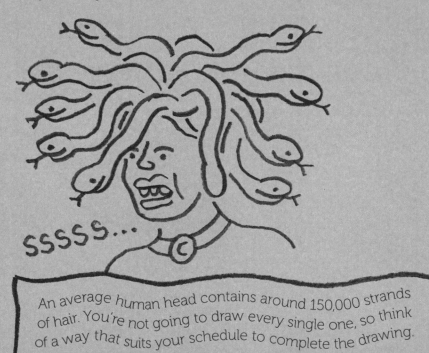

SSSSS...

An average human head contains around 150,000 strands of hair. You're not going to draw every single one, so think of a way that suits your schedule to complete the drawing.

GOOD POINT!

Drawing Hair

Draw a simple head shape, and maybe shoulders. Now, think about the type of hairstyle you want your portrait to have, and the texture and volume of the hair you intend to draw. Consider how much time you want to spend on it.

1 Start sketching first at the hair parting. Divide the hair shape into two forms if possible.

2 Hold the pencil loosely. If you let your hand flow, so too will the hair.

3 Draw thin lines, but don't try to draw every strand of hair! Thick lines will make the hair look clumped together.

4 Erase any stray lines.

5 Darken the hair with a B pencil to add shade and texture.

6 Add detail – hats, bands, hair ties, ribbons.

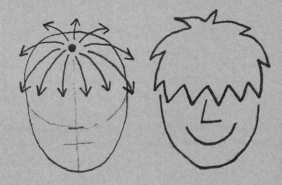

Things to Consider

1 INSPIRATION

For your drawing, how do you want the hair to look? Can you picture something original in your mind? Or are you copying a friend's hairstyle? Whatever the inspiration, have a reference photo nearby to constantly refer to.

2 VOLUME

Sketch a loose outline of the skull before you start drawing hair. Will your hair be thick, thin, wild, tame, tight or flowing? Consider the type of hair before committing pencil to paper. People with long hair have at least 2cm of hair height (and on the sides too) on top of their actual height.

3 FLOW

Long hair flows like a liquid. Consider the flow and movement of the hair. Begin by sketching the basic structure of the hair; keep your pencil strokes loose and simple.

4 VALUE (SHADOWS, MIDTONES, HIGHLIGHTS)

A full head of hair contains many shades, so before you start making marks, consider where the light source is coming from, the shadows and reflections and, finally, the tones. Devise a values scale (see page 36). Once you have an outline, begin shading the darker areas so you can see the big picture. Now add the finer details.

5 TEXTURE

Is the hair coarse or smooth? Fluffy or flat? Work on one part of the hair at a time, and only move on to the next when you're happy.

Always sketch different haircuts before settling on the right one for that particular drawing. Ask yourself whether it will look different from other people's hair in the sketch.

Pencil Facts #2

Despite pencils being used every day by people all over the world, it was quite a few decades after their rise in popularity that someone actually wrote about them! It was not until 1565 that Swiss national Conrad Gesner described a pencil. He mentioned it only as an aside in his *Treatise on Fossils*, but from his description, it became known that people in the 14th century were writing with a graphite rod contained within a wooden case.

If you took 15 billion pencils (the world's annual pencil production) and laid them end to end, they would stretch from the Earth to the moon almost seven times!

It is often believed that a typical HB pencil holds enough graphite to draw an unbroken line about 56km long or to write roughly 45,000 words, though it's never been tested. Frenchman Bernard Lassimone patented the first pencil sharpener in 1828, and Therry des Estwaux invented an improved mechanical sharpener in 1847.

It was French researchers in the 18th century who hit on the idea of using a vegetable gum by-product, *caoutchouc*, now known as rubber, to erase pencil marks. Up until then, artists removed mistakes with breadcrumbs!

The world's largest pencil is a Castell 9000. It is currently on display at Castell's plant near Kuala Lumpur. Made of Malaysian wood and polymer, it stands at 20m high!

How to Draw a Cartoon Skull

Skulls play an important part in art and art history. From Damien Hirst's £1 million diamond skull sculpture to the pop art imagery of Mexico's Day of the Dead festival, skulls symbolise the very essence of our humanity — underneath our skin, we all look the same. Get your skulls right and have the best decorations next Halloween.

Drawing Basic Skulls

1

Sketch out the basic oval shape of the skull – lightly. On top of this shape, draw a rectangle, overlapping as shown. Draw a dividing line to separate the bottom and top halves of the rectangle. Draw a parallel line towards the bottom of the rectangle, and a small line halfway between the two parallel lines. This smaller line will be the bottom of the nose.

2

Draw two cut-in lines as shown – these lines will form the jawline.

3

For the nose, draw a triangle. For the eyes, draw two big holes.

Add the curved line of the eyes and nose for the 3D look. Add expression to the mouth.

Decorate the rest of the skull with pattern or colour, or simply add 'fracture lines'.

Andy Warhol's 1962 pop art piece, *Campbell's Soup Cans*, is one of the most famous food-related works of art. Warhol chose soup cans as his muse because he wanted to immortalise 'something you see every day and something that everybody would recognise'.

GOOD POINT!

How to Draw Food

Drawing food from imagination is as easy as 1, 2, 3.

Choose an item of food you wish to draw. Picture it in your mind.

Without looking at the page, sketch the form of the food item quickly.

Add the detail.

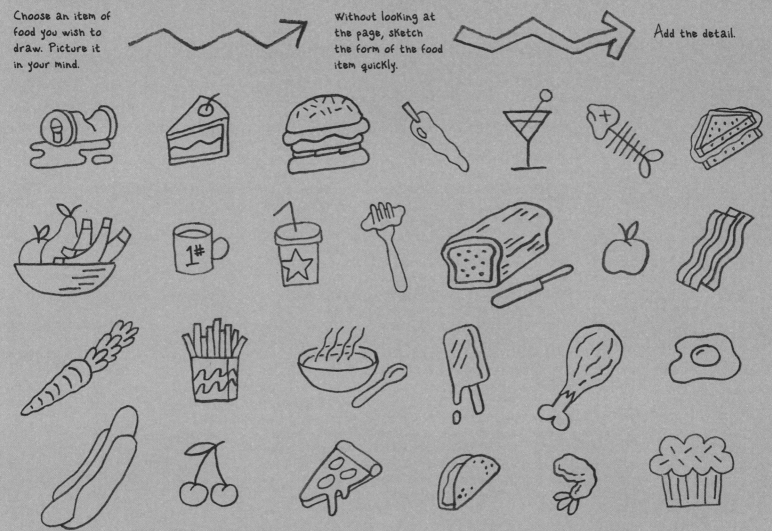

Drawing Styles

When it comes to drawing styles, you are the artist, and you can select whatever style you wish. Even choosing no style is a style! But having a working Knowledge of as many drawing styles as possible before committing your pencil to paper will ultimately benefit your finished work. Let's take a look at some popular drawing styles...

Realistic

Fine detail, realistic features, a focus on shading and texture. Subjects depicted as truthfully as possible. Photorealism and hyperrealism blur the lines between drawing and photography.

ExAMPLES
Rembrandt
Gustave Courbet
Lucian Freud

Manga Style

Characterised by stylised, colourful art, adult themes, movement lines, sharp edges and fine lines.

ExAMPLES
Kouto Hirano
Shigera Mizuki
Misuru Adachi

Loose and Messy

Defined by fast scribbles, a mixture of sharp and curved angles, lack of detail, overlapping lines.

ExAMPLES
Quentin Blake
Keith Haring
Picasso

Neat and Precise

Features sharp lines, 90° angles, a lack of detail, limited emotion.

ExAMPLES
Saul Steinberg
Julian Opie
Charles Sheeler

Classic Cartoon

Rounded features, soft edges and curves, as seen in:

ExAMPLES
Homer Simpson
Peter Griffin
Charlie Brown
Fred Flintstone
MicKey Mouse

DRAWING EXERCISE

For this task, draw the same thing – say,
a car – but in each of the drawing styles below.
Notice the difference in the way you think
and draw as well as the techniques used.

ABSTRACTION

Artists who work in an abstract
style end up with drawings that
are usually about shape, line,
colour and texture.

Famous abstract artists
Piet Mondrian, Joseph Albers,
Al Held.

MANGA

Manga artists draw characters
based on the Japanese comic
book style developed in 19th-
century Japan, with a concentration
on pace, movement lines and
sharp-angled features.

Famous manga artists
Osamu Tezuka, Machiko Hasegawa.

REALISM

If you're looking for convincing
representations of reality, look
no further than realism.

Famous Realist artists
Leonardo da Vinci,
Jean Auguste Dominique Ingres,
William Beckman, Steven Assael.

ART NOUVEAU

Art nouveau artists are famous
for flat but illusionist drawings
that are driven by intricate patterns
which incorporate curved lines.

Famous art nouveau artists
Gustave Klimt, Aubrey Beardsley,
Alphonse Mucha.

POST-IMPRESSIONISM

Post-impressionists were fixated
by light and geometric shapes.

Famous post-impressionist artists
Georges Seurat, Paul Cézanne,
Vincent Van Gogh.

SURREALISM

Dreamlike and always based
on pure imagination. Basically,
anything weird is welcome here!

Famous surrealist artists
Salvador Dalí, Marcel Duchamp,
Yves Tanguy.

Lettering and Type

Lettering is the process of creating illustrations with letters, numbers or any type of character or phrase and is an important art of graphic design and art. Look around you: from book covers to TV shows, brand logos to writing your own signature, lettering in all its various guises and forms is everywhere.

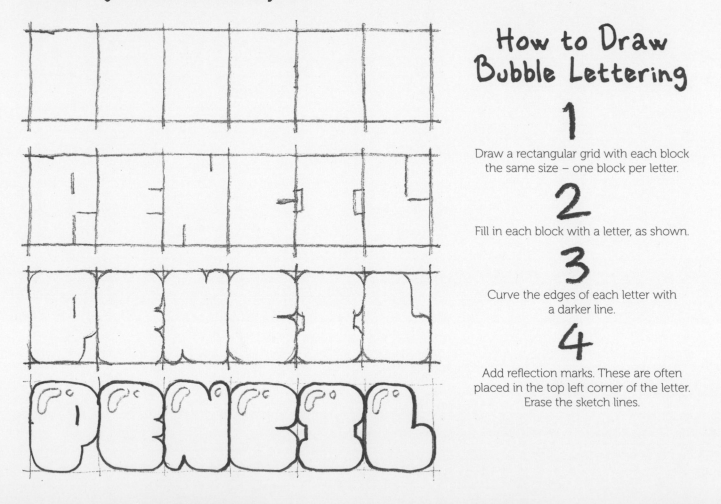

How to Draw Bubble Lettering

1

Draw a rectangular grid with each block the same size – one block per letter.

2

Fill in each block with a letter, as shown.

3

Curve the edges of each letter with a darker line.

4

Add reflection marks. These are often placed in the top left corner of the letter. Erase the sketch lines.

Chisel Lettering

1

Draw a rectangular grid, but this time made up of smaller block units. Outline your letters, using the grid as a guide.

2

Join up the corners inside each letter to produce a chiselled effect. Erase the sketch lines.

3

Depending on which light source direction you are aiming for, shade the opposite side. In this example, the light is coming from the above left.

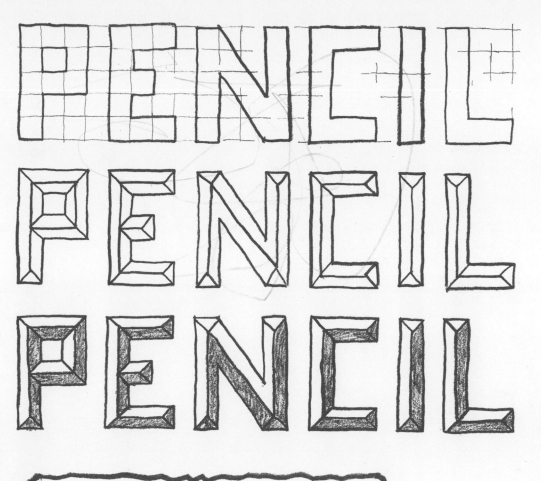

The Vox System

Most typefaces can be classified into one of four basic groups: serifs (letters with a small line attached to the end of each stroke of the letter), those without serifs (sans serifs), scripts, and decorative styles.

The font known as Helvetica is the most commonly used typeface in all of graphic design, and almost certainly the most widely used sans serif. It was developed by Max Miedinger in 1957.

Even More Letters!

Here are some other lettering styles to get your creative juices flowing. Note the differences. How would you classify them? Remember, type is designed to elicit an emotional response. How does this lettering make you feel?

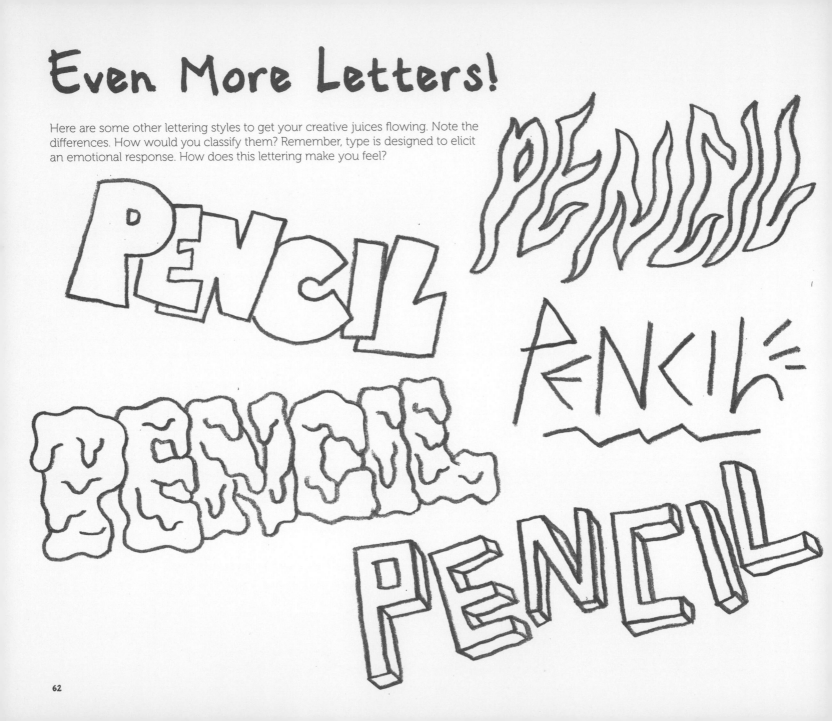

pencil

PENCIL

PENCIL

GOOD POINT!

Think of your favourite TV show, movie, band name, book cover or brand — each one has its own lettering style or logo. From *The Simpsons* to *EastEnders*, Netflix to Nike, specialised and unique lettering has infiltrated culture. Wouldn't it be boring if it was all the same — in Times New Roman?

As an exercise in creativity, why not try sketching your own 'brand' logo, or designing your own lettering for your name. Remember, the lettering style has to express your personality (i.e. soft edges for fun, hard edges for serious). Try it out!

How to Draw Scrolls and Flags

Scrolls and flags are a great way to position, fill and decorate lettering or text on a page. They're also very simple to draw, and once you know how, they'll become your favourite doodle.

Draw a Flag

1 Draw a flagpole. This is a long cylinder. Remember to plant the flagpole to the left of the page, to give yourself room to draw the flag.

2 Which direction is your flag blowing in – left or right? If it's blowing right, draw a line to the right of the flagpole, as shown.

3 Give the corners of the line above 'table legs' at a 45° angle.

4 Connect the table legs, as shown, to give your flag a 3D feel. Match the curve of the top line.

5 Colour and decorate the flag in your style!

The world's simplest flag belongs to Japan. It is comprised of a flat white background with a large red dot in the centre. The flag of Nepal, on the other hand, is the most unique and is comprised of two pennants.

Draw a Scroll

1 Draw a vertical line like so, with a curl at each end.

3 Draw two vertical lines on the right side, to join the scroll up. DONE!

2 Add horizontal 'table legs'.

4 If you're feeling fancy, add tear marks to give the scroll a medieval appearance.

GUY

If you want to add some medieval-style typography to your scroll, why not try some double-pencil calligraphy. Grab two pencils between your index and forefinger and write as you would normally. The effect is very interesting.

5 Decorate the negative space with your designs.

How to Add Colour

Coloured pencils can add all sorts of extra dimensions to your sketches, but only as long as you understand the science behind the way that colours work together. Turning the colours you picture in your head into a fully realised image is harder than you think.

Let's Spin the Colour Wheel

When working with colours, a colour wheel is something you should become familiar with. It helps you understand the relationships between certain colours. Let's have a look at hues. A hue is defined as the attribute of a colour by virtue of which it is discernible as red, green, etc., and which is dependent on its dominant wavelength and independent of intensity or lightness.

PRIMARY HUES
Red, blue and yellow. All other hues are made from these primary hues.

SECONDARY HUES
Violet, orange and green. Secondary hues are a blend of two primary hues and are located halfway between those primary hues on the colour wheel.

TERTIARY HUES
Red-orange, yellow-orange, yellow-green, blue-green, blue-violet and red-violet. Tertiary hues are a combination of a primary hue and a secondary hue.

ANALOGOUS HUES
Three to five hues next to each other on the colour wheel, such as red, red-orange, orange and yellow-orange.

COMPLEMENTARY HUES
Hues directly across from each other on the colour wheel, such as red/green, violet/yellow and blue/orange.

WARM / COOL HUES
Warm hues include the hues from red through yellow and yellow-green on the colour wheel.

Cool colours go from blue-green through blue to violet on the colour wheel. The leftovers – red-violet and green – appear warm.

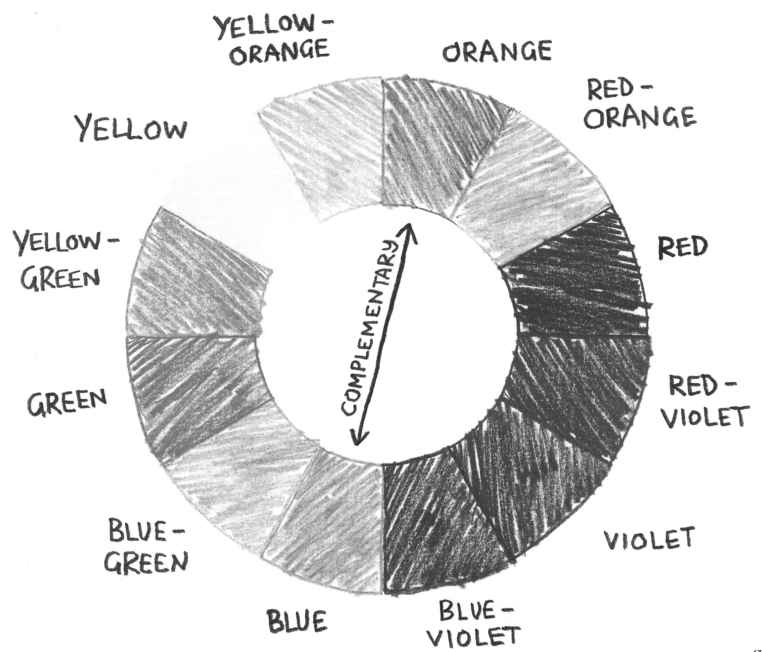

YELLOW-ORANGE

ORANGE

RED-ORANGE

YELLOW

RED

YELLOW-GREEN

RED-VIOLET

COMPLEMENTARY

GREEN

VIOLET

BLUE-GREEN

BLUE

BLUE-VIOLET

PRIMARY

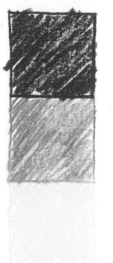

RED

BLUE

YELLOW

SECONDARY

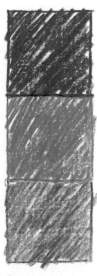

PURPLE

GREEN

ORANGE

TERTIARY

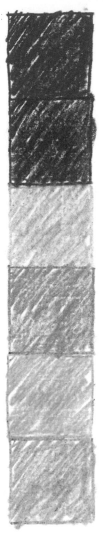

RED-VIOLET

BLUE-VIOLET

BLUE-GREEN

YELLOW-GREEN

YELLOW-ORANGE

RED-ORANGE

Plan what you are going to draw before you start sketching. Unlike graphite pencils, coloured pencils cannot easily be erased, so to avoid mistakes, be prepared!

TOP TIP!

COMPLEMENTARY EXAMPLE (OPPOSITES)

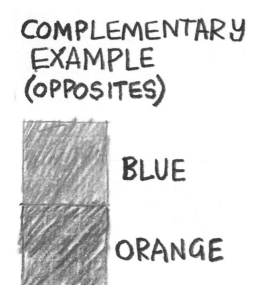

BLUE

ORANGE

Remember, keep your pencil strokes flowing in the same direction when colouring in. Too many lines going in different directions can ruin a sketch, unless it's a style you are aiming for.

It wasn't until the early 20th century that coloured pencils became popular. With a core made up of a combination of pigments or dyes instead of a graphite rod, today coloured pencils come in a huge range of colours for every purpose!

When doing a complex sketch, always shade the darkest tones first. It will give you a base to compare other tones to.

COLD COLOURS

WARM COLOURS

Battleships

Here are two classic pencil-and-paper games for two players. They are highly competitive and, I'm sorry to admit, educational. Both games will hone your use of logic and strategy. The object of Battleships is to sink all the other player's ships by guessing which squares they occupy on a grid and 'firing' at them. Doodle some submarines firing weapons as well — it is a great way to distract the other player!

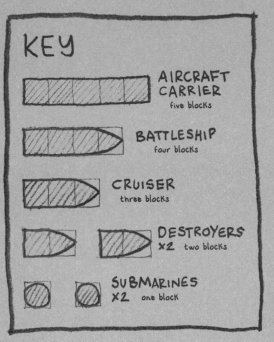

KEY

AIRCRAFT CARRIER	five blocks
BATTLESHIP	four blocks
CRUISER	three blocks
DESTROYERS ×2	two blocks
SUBMARINES ×2	one block

How to Play Battleships

1. Each player draws two grids. Label the X axis A–J, and the Y axis 1–10. Each player now secretly plots all their ships (see key) on one grid (ship grid) according to size.

2. Take turns to fire upon your opponent's ships by calling out grid points – for example: A5 or B7.

3. Record your shot as a hit (X) or a miss (O) on your second grid (attack grid) according to your opponent's reply.

4. When your enemy fires upon you, answer hit or miss, according to their shot. Mark your hit ships with an X on your ship grid.

5. A ship is sunk when your opponent has guessed every block of the ship correctly. You must inform your opponent that it has sunk and which ship it is, for example, 'My battleship has sunk!'

6. The first person to sink all of their opponent's ships wins the game.

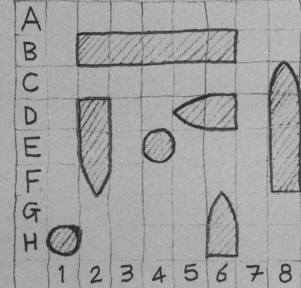

Sprouts

Invented in the early 1960s by mathematicians John Horton Conway and Michael S. Paterson, Sprouts is a classic pencil-and-paper game and requires you to apply logic and strategy to win. The object of the game is to make it impossible for the other player to draw a line. The last person to draw a line is the winner.

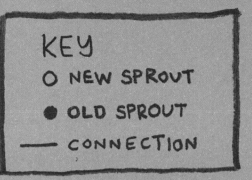

KEY
O NEW SPROUT
● OLD SPROUT
— CONNECTION

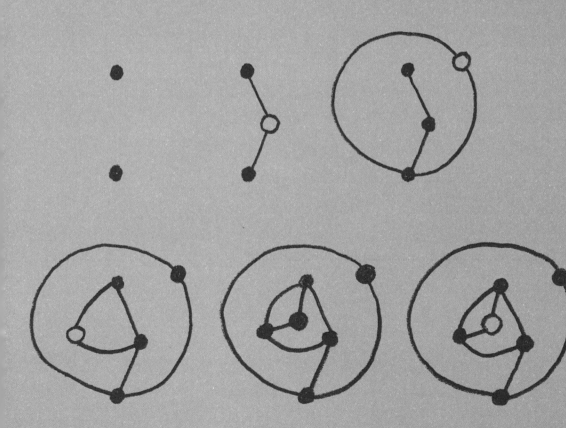

1 Grab a pencil and a piece of paper. Draw a couple of black spots.

2 Each player takes turns to join two of the spots with a line (or a line from a spot to itself), marking a new spot or sprout in the middle of the line. (Old sprouts are coloured in; a new sprout is depicted by an unfilled circle.) When a player is unable to connect available spots with a line, that player loses.

3 However, you have to follow the rules below. The last person to be able to draw a line is the winner.

a) You are not allowed to draw a line that crosses another line. This is important! Lines can be straight or curved.

b) A spot cannot have more than three lines leading to or from it.

Say Hello to Keith Haring

Despite dying tragically young in 1990, Keith Haring is an icon of modern art. As with many great artists, Haring was considered ahead of his time — energetic, prolific and dynamic. He even attended Madonna's wedding with art legend Andy Warhol as his guest — that's how cool he was! Let's pay tribute to the late, great artist by trying to understand what made him so great...

'WHATEVER YOU WANT TO DO, THE ONLY SECRET IS TO BELIEVE IN IT AND SATISFY YOURSELF. DON'T DO IT FOR ANYBODY ELSE.'

2 Haring focused on colourful graffiti drawings that contained a powerful message. His inspiration was found in the tunnels of the New York City subway system, where he would draw more than 40 subway chalk drawings per day.

'I COULD EARN MORE MONEY IF I JUST PAINTED A FEW THINGS AND JACKED UP THE PRICE. [I WANT TO] BREAK DOWN THE BARRIERS BETWEEN HIGH AND LOW ART.'

1 Haring learned how to draw by emulating the style of his father, a New York-based cartoonist. He became one of the most famous pop and graffiti artists of the 1980s. His works had fun with bold lines and colours.

What Do We Know?

3 He redefined what art was and meant for his generation, blurring the line between fine art and graffiti (which was considered to be vandalism at the time).

4 Haring painted a 91.5m mural on the Berlin Wall in 1986. This was considered a great achievement for a 'social activist artist'. The mural was painted over the next day.

'DRAWING IS STILL BASICALLY THE SAME AS IT HAS BEEN SINCE PREHISTORIC TIMES. IT BRINGS TOGETHER MAN AND THE WORLD. IT LIVES THROUGH MAGIC.'

Keith Haring

5 Haring would draw sketches for any fan who asked him! He didn't care that by doing so it would depreciate the financial value of his larger pieces.

6 On his deathbed, Haring drew one of his most iconic works – *Radiant Baby*. It was his way of saying goodbye to the world.

7 His 'dancing dog' is a leitmotif illustration that Haring drew throughout his career.

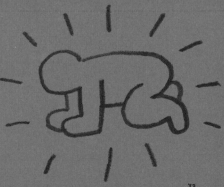

Drawing Jokes

How many Surrealists does it take to change a light bulb?

Two. One to hold the giraffe and the other to fill the bathtub with brightly coloured machine tools.

What did Michelangelo say to the ceiling?

'I got you covered.'

Did you hear about the artist who always took things too far?

She didn't know where to draw the line.

What did the artist say to the dentist?

'Matisse hurt.'

'You can lead a horse to water but a pencil must be lead.'

Laurel and Hardy

A motorcycle cop approached a motorist stopped in the middle of the road holding up traffic just before a river overpass. The officer noticed the driver wearing a beret and frantically scratching away in a sketchbook. He asked the driver, 'What in the world are you doing?' The driver replied, 'The sign says Draw Bridge!'

How did Salvador Dalí start his mornings?

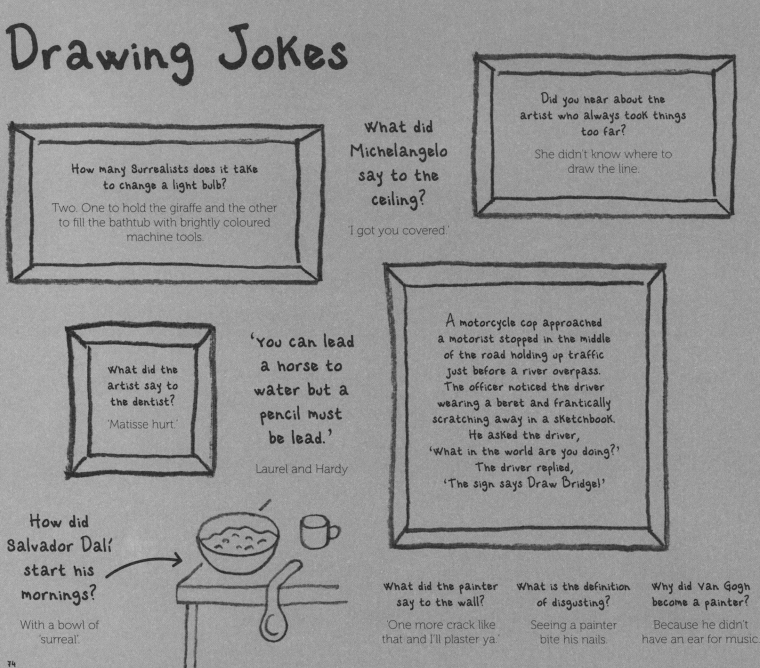

With a bowl of 'surreal'.

What did the painter say to the wall?

'One more crack like that and I'll plaster ya.'

What is the definition of disgusting?

Seeing a painter bite his nails.

Why did Van Gogh become a painter?

Because he didn't have an ear for music.

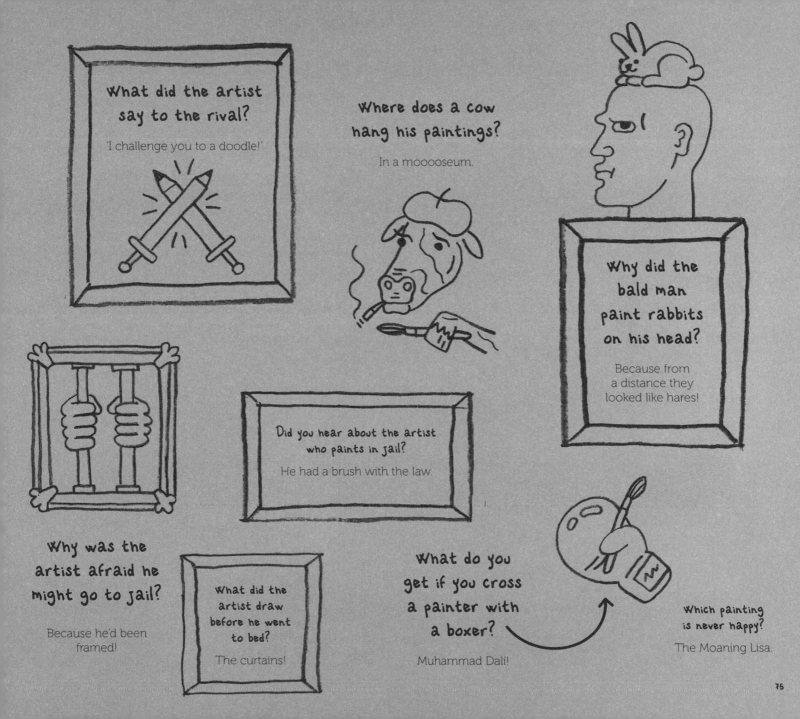

What did the artist say to the rival?

'I challenge you to a doodle!'

Where does a cow hang his paintings?

In a mooooseum.

Why did the bald man paint rabbits on his head?

Because from a distance they looked like hares!

Did you hear about the artist who paints in jail?

He had a brush with the law.

Why was the artist afraid he might go to jail?

Because he'd been framed!

What did the artist draw before he went to bed?

The curtains!

What do you get if you cross a painter with a boxer?

Muhammad Dali!

Which painting is never happy?

The Moaning Lisa.

How to Keep a Sketchbook

Sketching is an art form so brilliantly uncomplicated that it requires only a piece of paper and a pencil to begin. The rest is down to your imagination. A sketchbook is an artist's best friend. You should never go anywhere without one. Throughout history, artists have used sketchbooks as a place to safely store their sketches, make notes, write lists and be able to capture an idea as soon as it pops into their head. If you want to be a serious artist, get into the habit of Keeping a sketchbook. As Irwin Greenberg once said, 'An artist is a *sketchbook* with a person attached.'

Sketchbook Rules

1 Buy yourself a sketchbook that you really love. Enjoy its feel, its smell, its touch.

2 Never be precious about filling it. Write down anything you want to. If you need to, devise a structure for it – sketches at the front, lists at the back, for example.

3 Don't worry about getting it dirty. Cross things out, scribble, add Post-It notes. A dirty sketchbook is a tidy mind!

4 Draw from life. Go wherever the inspiration takes you.

5 Treat it like a scrapbook. Insert clippings, leaves, flyers, stickers – anything that fires up the imagination.

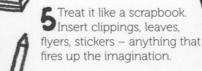

6 Experiment with materials. A pencil might be your weapon of choice, but buy other instruments and see how they feel. Use the sketchbook as a testing place for a variety of media.

Five Reasons you MUST Keep a Sketchbook

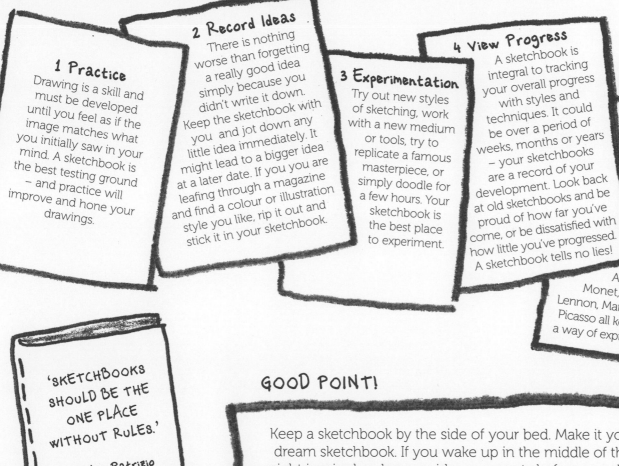

1 Practice
Drawing is a skill and must be developed until you feel as if the image matches what you initially saw in your mind. A sketchbook is the best testing ground – and practice will improve and hone your drawings.

2 Record Ideas
There is nothing worse than forgetting a really good idea simply because you didn't write it down. Keep the sketchbook with you and jot down any little idea immediately. It might lead to a bigger idea at a later date. If you you are leafing through a magazine and find a colour or illustration style you like, rip it out and stick it in your sketchbook.

3 Experimentation
Try out new styles of sketching, work with a new medium or tools, try to replicate a famous masterpiece, or simply doodle for a few hours. Your sketchbook is the best place to experiment.

4 View Progress
A sketchbook is integral to tracking your overall progress with styles and techniques. It could be over a period of weeks, months or years – your sketchbooks are a record of your development. Look back at old sketchbooks and be proud of how far you've come, or be dissatisfied with how little you've progressed. A sketchbook tells no lies!

5 Meditation
Art therapy, doodling, venting, creative expression – whatever you do, sketching is a beneficial way of de-stressing, decluttering the mind and finding your inner calm. Artists as diverse as Andy Warhol, Claude Monet, Frida Kahlo, John Lennon, Marc Chagall and Pablo Picasso all kept sketchbooks as a way of expressing themselves.

'SKETCHBOOKS SHOULD BE THE ONE PLACE WITHOUT RULES.'

Marilyn Patrizio

GOOD POINT!

Keep a sketchbook by the side of your bed. Make it your dream sketchbook. If you wake up in the middle of the night inspired, or have an idea moments before you drift off to sleep, having a sketchbook close at hand will ensure that the idea is never lost. Leonardo da Vinci only made a few paintings, but we all know him and revere him because of the ideas he recorded in his sketchbooks.

The Science of Doodling

Dreaming that you are sharpening a pencil suggests that you need to be more flexible. Seeing a pencil in your dream indicates your relationship may not last!

If you are waiting for someone to arrive, or are on a slow train with nothing else to do, and all you have with you is a pencil and notebook, the chances are you'll start doodling. But did you know that what you choose to doodle reveals volumes about your personality and mood? Let's investigate further.

What Are Doodles?

Doodles are shapes, patterns, drawings or scribbles – anything we produce in an idle moment while the focus of our attention is elsewhere.

What Your Doodles Say About You

Faces

The expression you draw on a doodled face is sometimes a very close indication of your own mood. A softly drawn, round face suggests you see the best in people, or that you are happy. Inversely, if a weird or ugly doodle is drawn, you are no doubt in a negative state of mind. A comic face doodle suggests neediness, whereas side profiles indicate you're an introvert.

Flowers

If you doodle soft, rounded petals enclosing the centre of a flower, this indicates you are a friendly, family-oriented person. If you doodle a bunch of drooping flowers, however, this indicates you're burdened by worry.

Hearts

Obviously a romantic doodle. Drawing a heart indicates you're in love!

Stairs or Ladder

A doodle of stairs or a ladder signifies ambition and an eagerness to work your way 'up the ladder' in life. It can also imply that you have an important job or task coming up.

Boats and Planes

Doodling any form of transport often indicates a desire to escape from a situation.

House

A neat drawing of a house suggests a secure home life. A messy-looking doodle indicates unhappiness at home.

Spider's Web
Any intricate doodles, such as a spider's web, symbolise a feeling of being trapped.

Names or Initials
Doodling your name or initials is common in those who enjoy being the centre of attention.

Stars
Stars are often drawn by go-getters. A pattern of lots of little stars indicates you are optimistic. If you've drawn one big, decorated star, it means you've got a target or goal you want to achieve.

Squares or Boxes
Doodling any type of box indicates your desire to control a situation and that you are seriously thinking through a problem. If you progress to doodling a cube this suggests you are a highly efficient and analytical person who can deal with difficult situations.

Zigzags
Patterns made up of soft, flowing, curvy lines suggest a similar approach to your affairs; zigzags and harsh, angled patterns made up of lots of straight lines indicate energetic thinking and a desire to progress quickly.

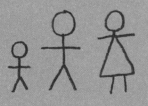

Stick Figure
The stick figure reveals someone who is in control of their emotions and incredibly focused on their goals in life. It is a doodle commonly made by highly successful people.

'WE TEND TO DOODLE WHEN WE ARE BORED OR STRESSED. BECAUSE OF THIS, WE'RE USUALLY ONLY HALF-CONSCIOUS OF WHAT WE'RE DRAWING — WHICH MEANS OUR INNER PREOCCUPATIONS SURFACE ON PAPER.'

Ruth Rostron,
British Institute of Graphologists

GOOD POINT!

The way a doodle is drawn can also indicate the doodler's true intentions. For example, emotional people who crave affection and attention use rounded shapes and curved lines. Down-to-earth, practical types tend to doodle straight lines and squares. Ambitious people will use corners, zigzags and triangles, while more hesitant types use light, sketchy strokes. Outgoing people often make large doodles, while shy people make smaller ones.

The Super S

The 'Super S', 'Stussy S' or 'Stussy' is a well-known doodle that everybody learns how to draw as a child. Consisting of 14 lines that form a stylised 'S', the symbol is usually doodled subconsciously by those who are bored.

In the 1980s and 1990s, many schools banned students from drawing the Super S, because they believed it was associated with gang culture, or was a distraction during lessons.

Origins

While many artists believe the origin of the Super S is a mystery, it actually first appeared in a puzzle book published by Scholastic Books. The original puzzle shows two rows of three vertical lines. The challenge posed to the reader was to turn them into the letter S by adding eight more straight lines. It seems easy, but can you do it? No cheating!

How to Draw It

The Super S has become infamous because, really, it is a simple puzzle: can you make an S out of these six lines? Here's how it's done:

1 Draw three parallel lines.

2 Draw another three parallel lines under the first lines.

3 Connect the lines with other lines. It should start resembling a Super S.

4 Connect a few more lines and put points on each end.

Once you solve it, you'll find yourself doodling it again and again, just as people enjoy drawing things like 3D cubes and hatched patterns – once they learn how.

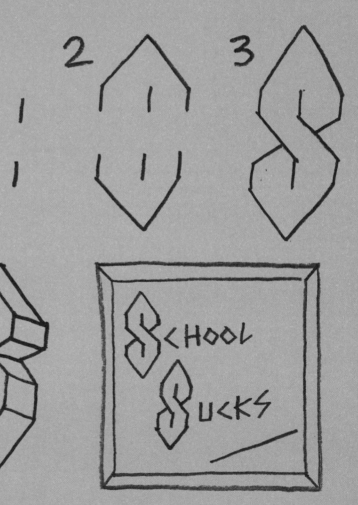

Kilroy

Remember when you were young and you used to scrawl 'John woz 'ere' (or whatever your name is!) on any available surface? Well, the origins of that lie in a very famous sketch that takes us back in time.

The words 'Kilroy was here' and a simple drawing of a face peeking over a fence were scrawled on walls in Europe by US soldiers during the Second World War. If you saw Kilroy, it usually meant that the US Army had arrived and that allies of the US were now safe. Kilroy's face became so ubiquitous wherever American servicemen went in Europe during the war, that rumours suggested that Adolf Hitler himself had issued orders to find and kill Kilroy, whoever he was!

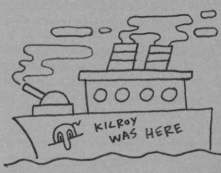

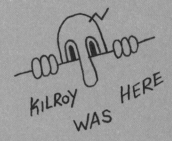

How to Draw a Kilroy

Draw a dash followed by three ovals.

Leave a gap, then reverse step 1 – draw three ovals, followed by a dash.

In the gap, draw a half-oval.

Draw two black dots for eyes. Add a nose, and complete the wall.

Final touch – add '[insert your name] woz 'ere' next to it.

Doodle this everywhere you go!

How to Draw a Dog

From Scooby to Snoopy, Pluto to Krypto, dogs have taken a walk across the pages of every type of art medium possible. Here's our four-step process to drawing a good dog...

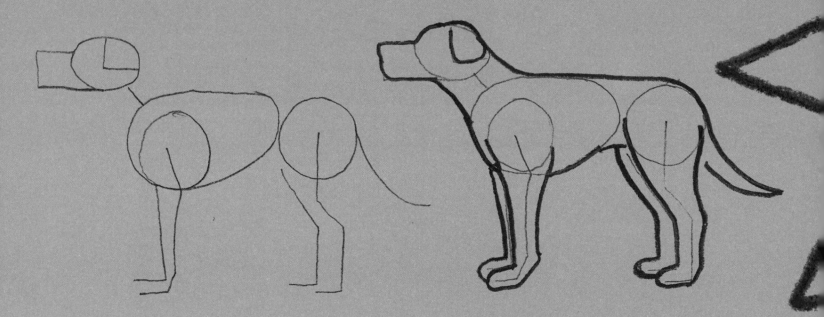

1 Think about the type of dog you want to draw as well as the overall appearance – size, light source, movement, etc. For this example, to keep it simple, we're drawing a standing dog. Using your knowledge of shapes (see page 32), lightly sketch the position and body of the dog. This is the wire frame, or skeleton, upon which we'll hang our dog's body.

2 With a thicker pencil, or a darker line, add detail to the shape, paying attention to curves.

3 Add detail to the face and add a bone or stick on the floor, for flavour.

GOOD POINT!

Many famous artists have become well-known for using their canine pal as their muse – Frida Kahlo, Edvard Munch, Lucien Freud, Keith Haring (see page 72), Charles Schulz, Andy Warhol, Norman Rockwell and David Hockey, to name just a few. One of the most famous dog drawings of all time, however, is Pablo Picasso's black line drawing of Lump, his favourite dachshund. Picasso's best friend inspired the artist to write, 'Lump, he's not a dog, he's not a little man, he's somebody else.' The dog died ten days before Picasso did.

How to Draw a Cat

Despite being one of the laziest pets on Earth, cats are notorious for not being able to sit still during portraits. Thankfully, they're easy to draw when in this position. Here's how...

What do you call a painting by a cat?

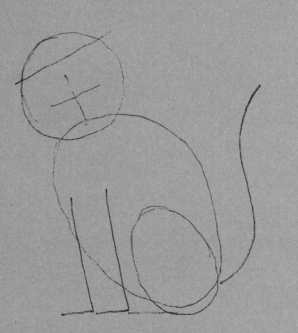

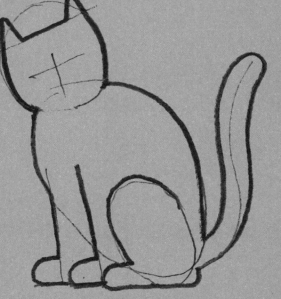

1 First things first: draw a circle for the shape of the cat's face. Next, draw two circles for the body. Then draw two vertical lines at the base for the cat's front legs. Draw a single line for the tail.

2 Erase the sketch lines once you've completed your cat outline properly. With a thicker line, draw a line around the body and head of the cat, in the shape that you want to draw it. Define the front legs and tail shape.

A paw-trait.

3 Now, draw the cat's face in detail. Sketch the eyes, nose and mouth in the style you are aiming for – simple or more intricate? Don't forget to draw the cat's whiskers.

MEOW!!

GOOD POINT!

One of the world's strangest cat artists is Louis Wain. He drew his cats and kittens with anthropomorphised and enlarged eyes, during the turn of the 20th century. H. G. Wells, who wrote *The War of the Worlds*, said of Wain: 'He has made the cat his own. He invented a cat style, a cat society, a whole cat world. English cats that do not look and live like Louis Wain cats are ashamed of themselves.'

Lineography

Lineography is the art of drawing without lifting the pencil off the page. The results can be staggering once mastered. The aim is to create a complex doodle or drawing without taking your pencil tip off the page.

Grab your pencil and a piece of paper. Let's start off with a heart.

Or a fist?

Can you draw an eye?

How about some glasses?

Once you've mastered these, let's try something a bit trickier... Gun, bottle and tent... go!

Single-line drawing requires concentration and excellent hand-eye coordination – similar to buzz-wire children's games such as Operation.

Have you completed it? Great. This one's for experts... Can you go from a head to a hand to a flower to a wine glass in one go?

GOOD POINT!

Single-line drawing is a lineographic technique that became ultra-fashionable in the early 1960s with the invention of the classic children's toy, Etch A Sketch, by André Cassagnes. Still available today, the Etch A Sketch helped aspiring artists, and pacified bored children, by being both entertaining and artistic at the same time. More than 100 million have been sold.

How to Draw a Straight Line — Without a Ruler!

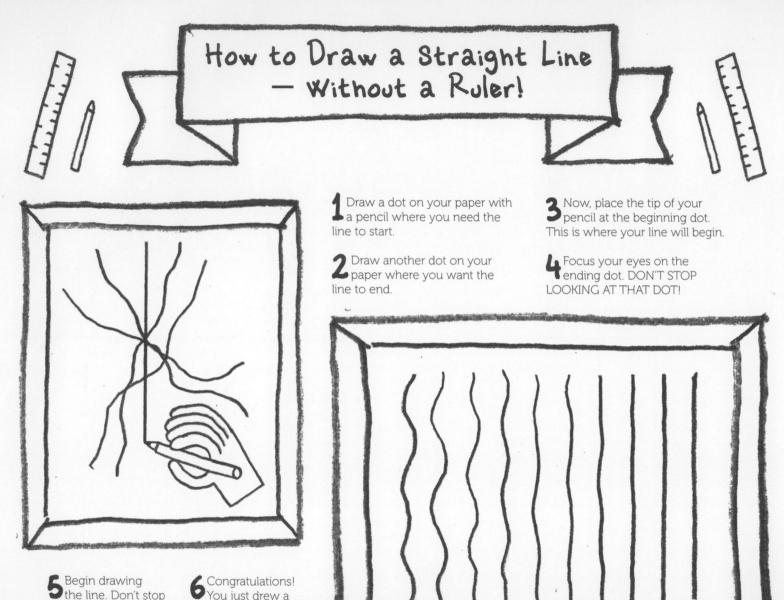

1 Draw a dot on your paper with a pencil where you need the line to start.

2 Draw another dot on your paper where you want the line to end.

3 Now, place the tip of your pencil at the beginning dot. This is where your line will begin.

4 Focus your eyes on the ending dot. DON'T STOP LOOKING AT THAT DOT!

5 Begin drawing the line. Don't stop until it reaches the ending dot. DON'T STOP LOOKING AT THAT FINAL DOT!

6 Congratulations! You just drew a straight line without using a ruler.

How to Draw a Perfect Circle

Imagine this. You're stuck in the woods. You're all alone. Nobody can save you and you desperately need to draw a perfect circle. Don't worry. If you have your trusty pencil, anything is possible!

2 Hold the pencil at a 45° angle — the size of the circle depends on where you hold the pencil.

1 Hold your thumb against the paper.

3 Hold the pencil still, but rotate the paper.

Pencil Tools

Anything is possible with your trusty pencil (and a few sheets of paper) by your side. But in order to really excel as a doodler extraordinaire, it might be worth acquiring some other helpful tools to get the job done right.

What You Need

On these two pages you'll find just about everything you might need.
One of the great things about being a sketch artist is that you don't really need much to do it. This list excludes pencils, which we assume you already own!

- Eraser – rubber
- Eraser – art gum
- Eraser – kneaded/putty – cleaner to use
- Eraser – vinyl
- Pencil erasers
- Protractor – for drawing smooth curves
- Compass
- Ruler and a set square – a must for drawing straight lines
- Sharpener
- Chalk piece
- Paper!

'LIFE IS THE ART OF DRAWING WITHOUT AN ERASER.'

John W. Gardner

Rather than have all your supplies rolling about on your desk, get hold of a glass jar and keep all your equipment in one safe place!

You'll also need a light. You won't draw anything in the dark, will you?

How to Spin a Pencil Around Your Thumb

Whenever you see someone flip a pencil around their thumb or middle finger, don't you always wish you could do that? Well, now you can. Just follow these simple, step-by step rules...

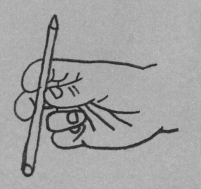

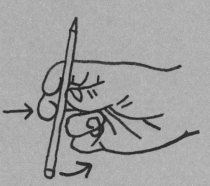

1 Hold the pencil between your index finger, middle finger, and thumb in your dominant hand – your index and middle fingers should be spaced apart from each other by about the width of your thumb. Experiment to find which part of the pencil you should grip. Some people prefer to grip a pencil in the middle, near its centre of gravity, while others grip at the end of the pencil.

2 Pull or flick your middle finger inwards as if you were pulling the trigger of a gun. This should make the pencil twirl around your thumb. If you're having trouble doing this, re-examine your grip. Your middle finger and thumb could be too close to each other.

3 Now, roll your wrist to help twirl the pencil around your thumb. Beginners often find they have difficulty making the pencil spin completely around the thumb. Rolling your wrist (as if turning a doorknob) as you pull with your middle finger should help.

Pen Spinning in the Movies

Perhaps the most famous pen-spinning moment to date is in the James Bond film *GoldenEye*, when evil computer boffin Boris twirls his spring-loaded pen around his finger, clicking it while trying to concentrate. In the finale Boris gets hold of 007's nifty pen grenade gadget and manages to detonate not only the pen but also his plans for world domination.

GOOD POINT!

Pen spinning is a form of contact juggling. Once you have mastered simple pen-spinning tricks such as the ThumbAround, FingerPass, Sonic and Charge, there are many more advanced tricks to learn with very cool names, such as the Wiper, Shadow, Hai Tua, Pun New, Continuous Bust, PalmSpin and Fingerless ThumbAround.

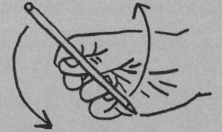

4 Don't obstruct the pencil with your other fingers as it is spinning. You can prevent this happening by tucking in both your index and middle fingers so that they are under the joint of your thumb.

5 Now for the most important part: catching the pencil. The coolest part of spinning a pencil is being able to repeat the trick over and over. You can only achieve this if you catch the pencil.

REMEMBER

Like any feat of hand dexterity, practice makes perfect. Once you master the trick in your dominant hand, switch to the other hand!

Feel the Force

When you pull in your middle finger like a trigger, remember that too much force will cause the pencil to shoot off in a crazy direction, but if you use too little force, the pencil won't make it all the way around your thumb. You'll soon get a sense of how much force makes your pencil spin perfectly every time.

Animate Your Own Flipbook

Take your doodles one step further and make your own animated flipbook. The practice of doodling a flipbook when you're bored has slipped out of fashion, so let's bring it back! It is much more creative than whiling away time by messing about on a smartphone. Flipbooks are easy to make, and they test your observational skills and allow you to hone your drawing skills while being creative. Also, they can be about anything you choose!

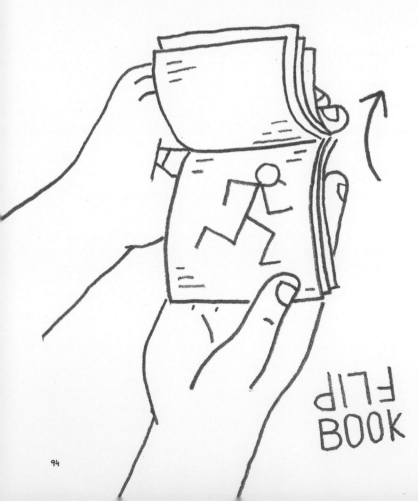

No Flippin' way!

An English lithographer by the name of John Barnes Linnett is credited with inventing the flipbook as we know it, in 1868. He named it the Kineograph.

Make a Simple Flipbook

Let's start off by making a very quick flipbook animation. Once you've mastered this, you can progress to making bigger and better ones...

1 Get a large Post-It pad, or you can use the corners of your sketchbook.

2 Choose a subject, a scene or an idea. It could be a bouncing ball or a growing flower. A bouncing ball is a simple drawing to start with – you can always expand it into a person later

on by drawing arms and legs that change position. Remember: a bouncing ball will squash on impact with the ground and stretch on the way up into the air.

3 Start with a design or character that you really want to animate. Stick men are always

fun – quick to draw and simple to move about!

4 Locate the bottom page of the pad. You *could* start at the top page, but this makes it harder to achieve a smooth animation as you will be unable to reference or trace the preceding drawing.

A Post-It notepad is ideal for a simple flipbook. The paper is thin enough to flick and it's a handy size to hold too. Remember: the more 'frames' or pages your flipbook has, the more realistic it will look. For a simple flipbook, about three pages per second will work fine. Modern films have between 24 and 30 frames each and every second!

Make your marks very lightly at first. Once you get to the end of the flipbook, test it. If it works, go back to the beginning and darken the lines. Then add any detail. Remember, anything you add now has to be repeated for the whole book!

1 2 3 4

5 Draw the first figure or object here. Use a pencil, so that you can erase any mistakes.

6 Turn to the next 'frame' or page. You should be able to see your first drawing through the sheet. If the lines are drawn too lightly, darken them, as it's important that you can see through the page well enough to trace or copy for the next frame.

7 If your character or object is moving, draw it in a slightly different location to the preceding image.

8 If your character needs to stay still, draw it in the exact same place, or trace over the preceding drawing.

9 Big changes in the drawing will appear as fast motion when you flip through, and smaller changes will seem slower. So judge the speed of your scene as best as you can. Practice will make perfect!

10 Repeat the process until you get to the end of your chosen scene.

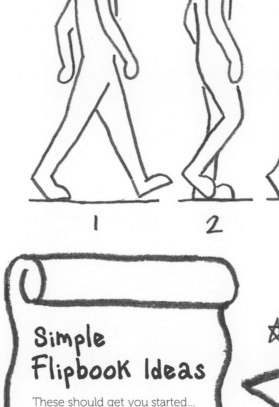

Simple Flipbook Ideas

These should get you started...

- A gun firing a bullet
- A flower growing out of the ground
- An apple being slowly eaten
- A person doffing their hat
- A slow-motion explosion of someone opening a fizzy drink can

GOOD POINT!
Flipbooks don't have to be drawings. You can use photos as well.

How to Draw a Comic Strip

Comic books form the foundations of much of our storytelling in the 21st century. Many of the biggest characters in films all started life confined to a small cell block — a comic strip. Writing your own comic book is a great way to learn about using space and perspective too, as you have to work with within limited borders.

Create Your Own Simple Comic Strip

Let's start by making our very own three-panel comic strip. Don't be afraid to think outside the box – feel free to have your characters move in, around, on top and underneath the panel cell, if that's what you want.

1 Come up with a story, joke or idea that you want to put into comic strip format. A three-panel comic strip is easiest – it lets you set up a story, build it up, and then deliver a punchline. Go away for a few minutes and think of an idea. We'll wait here until you've thought of one. Off you go!

2 Still waiting.

3 Have you thought of a story, joke or idea yet?

4 You have? Good.

5 Let's continue. Now you have your three-panel idea, quickly sketch it out in your sketchbook, remembering to write down funny words, phrases or jokes you wish your character to say, as well as the drawing style and tone. Got it?

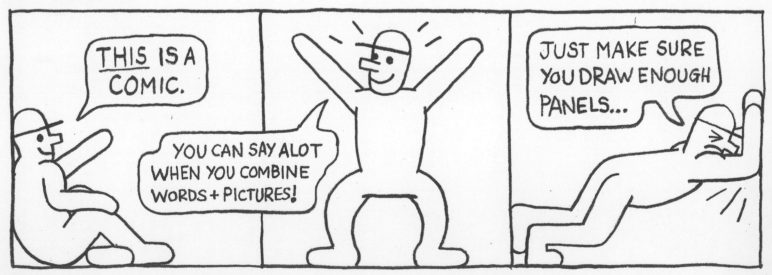

THIS IS A COMIC.

YOU CAN SAY A LOT WHEN YOU COMBINE WORDS + PICTURES!

JUST MAKE SURE YOU DRAW ENOUGH PANELS...

6 Choose your size. Most newspaper cartoons consist of three to four 7.5cm panels. For this example, draw three panels using a ruler.

7 Begin drawing your comic. Focus on one panel at a time. Draw with a light pencil so that you can alter things easily. As you draw, remember to leave space for speech bubbles or dialogue boxes.

8 When you're happy with your drawings, go over the lines in a darker pencil, and add colour.

9 Step back and admire your work!

STRIP TEASE

Comic strips come in three formats.

SINGLE-FRAME COMIC usually humorous in nature and relies on a visual gag and just one or two lines of dialogue.

COMIC STRIP Consists of a sequence of around 3—6 frames, depending on subject.

COMIC BOOK This is a larger format — the cartoonist will use a whole page, split into frames of their choosing, to provide a flow of narrative.

THINK OUTSIDE THE BOX

The popular cartoon *Cyanide & Happiness* breaks all the rules of the comic strip. The stick-men characters hang from and jump outside their panels, tell sick jokes and poke fun at the comic-strip medium itself.

GOOD POINT!

One of the most popular cartoon formats is the 'gag-a-day' type made up of three panels.
1. Sets up an introduction or character.
2. Builds up the joke or message.
3. Delivers the punchline or climax. Can you write a three-panel comic strip?

BE LIKE BILL

A popular Internet stick-man cartoon, Bill, is currently appearing on Facebook timelines with his tongue-in-cheek advice about the correct way to behave online and modern etiquette. Asking his audience to 'Be Like Bill', Bill first started appearing online in 2014, and now boasts more than 1.25 million likes on Facebook. 'The idea is very simple,' says creator Eugeniu Croitoru. '"Bill" can be anyone who is smart and has common sense and doesn't do annoying things.' Check Bill out!

A comic isn't just about a drawing. It's about the type, too. A comic's lettering can help your comic stand out and set it apart from others, so either create your own font, or replicate one that is in the style you are looking for.

Say Hello to Quentin Blake

Quentin Blake is, without question, the master of turning a messy line drawing into a beloved work of art. Children of several generations have grown up with his illustrations, and he is considered a legend of his time. Not only did he perfectly illustrate many of Roald Dahl's classic children's stories, but he also fired up the imaginations of aspiring artists all over the world, leading them to get their sketchbooks out and use their pencils like a wizard's wand — and create magic!

Quentin Blake — What Do We Know?

1 Born in 1932, he started drawing at the age of five.

2 Quentin studied English at Cambridge, before attending Chelsea Art College.

3 His first drawings were published in *Punch* magazine at the age of 16 and he has since illustrated more than 300 books by 80 different writers – including his own!

4 Blake was voted 'The Illustrator's Illustrator' in 1990.

5 He is the author of 30 books, including *Angelica Sprocket's Pockets*, *Cockatoos* and *Mister Magnolia*.

6 Sir Quentin Blake was knighted for his services to art in 2013.

7 He likes drawing dragons the most. 'Dragons are good because you can arrange them in interesting ways across the page, get people to ride on them.'

8 His character drawings always begin with the nose. 'I start with a nose. This is because facial expressions and gestures are the most difficult to get right; and I build the rest of the drawing around that. My studio is full of discarded pieces of paper with unfinished faces, or hands and arms, and nothing else!'

10 Quentin's tip for beginners is: 'Draw an enormous amount if possible – it helps you discover your own natural way of drawing, and out of that your style will emerge.'

9 His rough initial sketches are drawn 'spontaneously' with a fibre-tipped italic fountain pen.

12 In *Mrs Armitage on Wheels*, one of his own books, Blake deliberately gave his heroine a scarf that would blow in the wind, to impart the feeling of movement everywhere she went. 'Movement, freedom, escape are of the essence!'

11 Quentin's scratchy, angular line drawings are instantly recognisable. Develop your own style, he says. 'Muck about!'

13 His favourite book of Roald Dahl's to illustrate was *The BFG*.

Campaign for Drawing

Quentin Blake has supported the Campaign for Drawing since its creation in 2000. The charity has one aim: to get everyone drawing! The campaign's work will finish when the words 'I can't draw' are dropped from our national vocabulary. The charity believes: 'Drawing helps us to understand the world, think, feel, shape and communicate ideas. It is fun, accessible and invaluable – in education and everyday life.'

'WHEN I DRAW A CHARACTER, I TRY TO MAKE IT DEFINED – BUT NOT TO CLOSE IT UP COMPLETELY. IT'S AS IF I'M A GO-BETWEEN BETWEEN THE WRITER AND THE READER.'

Pencil Hacks

Pencils aren't just for drawing, you know. Pencils, our trusty best friends, can also help us get out of all sorts of sticky situations that life throws at us on a daily basis. This is why you should never, ever lend your pencil to anyone else.* Who knows when you might need one?

*Unless you have plenty of spares!

#1 Turn a pencil into a six-sided die
No dice for a board game? Don't worry! Just write the numbers one to six on each side of a hexagonal pencil and roll it instead!

#4 Check the sharpness of a pencil sharpener!

#3 Dip the tip of your pencil in water to create more defined lines.

#2 Create a phone stand
Watching a video on your smartphone is not much good if you have to hold it all the time. Grab a few rubber bands and four pencils and you'll be all set. Tie the ends of three pencils together with a rubber band, to form a tripod. Make sure it's steady. Between one pencil leg and another place a pencil horizontally and use a rubber band to fix it at each end. Place your phone on the horizontal pencil, and voilà! You have a phone stand.

#5 Pencils are great for scratching your back!

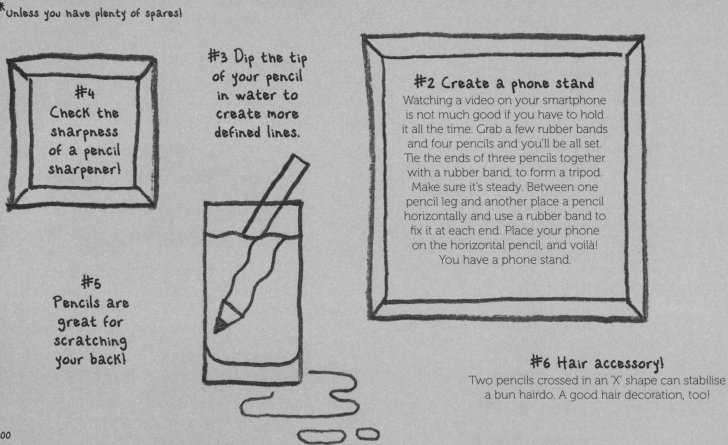

#6 Hair accessory!
Two pencils crossed in an 'X' shape can stabilise a bun hairdo. A good hair decoration, too!

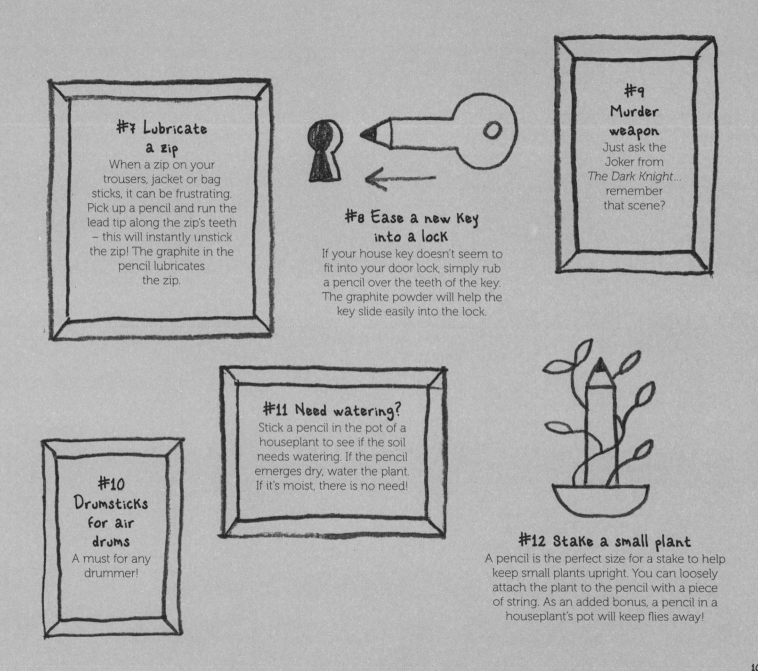

#7 Lubricate a zip

When a zip on your trousers, jacket or bag sticks, it can be frustrating. Pick up a pencil and run the lead tip along the zip's teeth – this will instantly unstick the zip! The graphite in the pencil lubricates the zip.

#8 Ease a new key into a lock

If your house key doesn't seem to fit into your door lock, simply rub a pencil over the teeth of the key. The graphite powder will help the key slide easily into the lock.

#9 Murder weapon

Just ask the Joker from *The Dark Knight*... remember that scene?

#10 Drumsticks for air drums

A must for any drummer!

#11 Need watering?

Stick a pencil in the pot of a houseplant to see if the soil needs watering. If the pencil emerges dry, water the plant. If it's moist, there is no need!

#12 Stake a small plant

A pencil is the perfect size for a stake to help keep small plants upright. You can loosely attach the plant to the pencil with a piece of string. As an added bonus, a pencil in a houseplant's pot will keep flies away!

#13 Repel moths

Pencil shavings are a great moth deterrent, as it turns out. Keep your jumpers whole (with no little holes) by placing a small cloth bag filled with pencil shavings at the bottom of your wardrobe.

#14 Make a splint in an emergency

Broken your finger? A pencil tied tightly (not too tightly) around the finger can act as a splint, ease the pain and stop the finger from bending.

YOU KNOW YOU'RE A PENCILHOLIC WHEN...

- You butter your toast with your fingers, just to feel its texture.
- You carry a sketchbook everywhere you go.
- You become that person at a party drawing people in the corner and describe yourself as a 'people watcher'.
- Your hands always have graphite smudges on them.
- You are always tripping up on pencils that have fallen on the floor.
- Your stir your tea with a pencil.
- Your nails are nice and tidy, but your pencil ends are chewed to death.

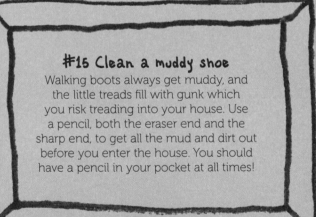

#15 Clean a muddy shoe

Walking boots always get muddy, and the little treads fill with gunk which you risk treading into your house. Use a pencil, both the eraser end and the sharp end, to get all the mud and dirt out before you enter the house. You should have a pencil in your pocket at all times!

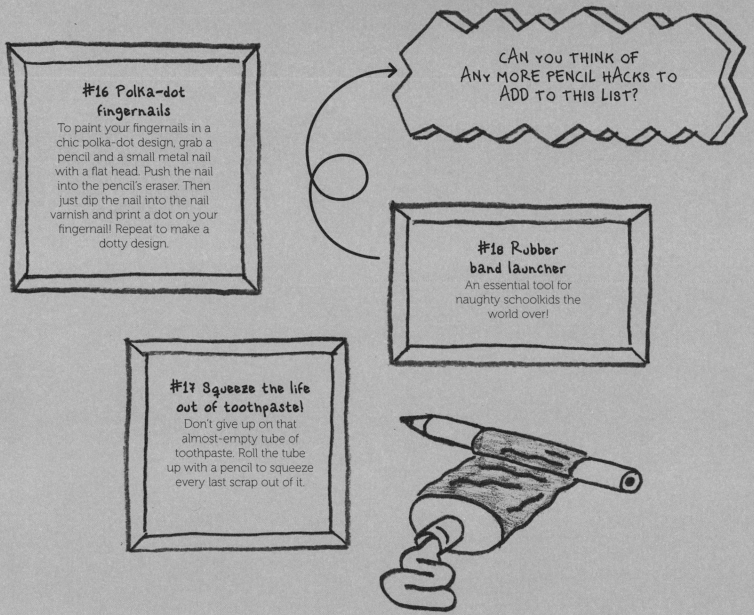

#16 Polka-dot fingernails

To paint your fingernails in a chic polka-dot design, grab a pencil and a small metal nail with a flat head. Push the nail into the pencil's eraser. Then just dip the nail into the nail varnish and print a dot on your fingernail! Repeat to make a dotty design.

CAN YOU THINK OF ANY MORE PENCIL HACKS TO ADD TO THIS LIST?

#18 Rubber band launcher

An essential tool for naughty schoolkids the world over!

#17 Squeeze the life out of toothpaste!

Don't give up on that almost-empty tube of toothpaste. Roll the tube up with a pencil to squeeze every last scrap out of it.

Avoid Common Drawing Mistakes

Drawing, like learning to play a musical instrument, can be a long, frustrating process where mistakes outnumber the rewards, at first. However, practice makes perfect, and you can cut down on mistakes simply by adhering to these rules...

1

USE MORE THAN ONE PENCIL

Don't stick to one tool – different pencils and implements will help change the way you draw without you even realising it. Pencils come in a variety of different lead hardnesses, each one producing different shades (see page 10).

USE THE RIGHT PAPER

4

One of the most common mistakes beginners make is to use the wrong paper to draw on. Don't just settle for cheap printer paper. Use a thicker paper (70lb or more) with a little bit of texture.

DO wHATEVER YOU LIKE

It's good to learn proper techniques, but ultimately you must do what you enjoy and create what looks good to you. If you want to draw everything flat and with no perspective, then go for it. Make drawing fun.

TURN THE PAPER AROUND

2

It's much easier to draw a straight line down a page than across it. So turn the paper around if you need to, and then turn it back. You'll end up with straighter lines.

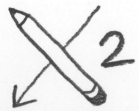

PROPORTIONS AREN'T PERFECT

5

Is anything in life perfectly symmetrical? Train your eyes to find the uneven proportions in everything you see. Look at your hands now and at how un-perfect they are. Remember, capturing this unevenness in life makes drawings believable.

6

THE DEVIL IS NOT IN THE DETAILS

Many beginner artists try to get fine details right straightaway. Don't. Instead, focus on making big shapes and forms correct – everything else will follow. There is nothing more frustrating than putting a lot of hard work into the detail only to have to erase everything because the initial drawing was wonky. Details always come last.

DRAW THE WHOLE PAGE

Once you start a drawing, make sure your pencil touches every part of it, even if it's very lightly. If you're drawing teeth or eyeballs, don't leave them the same colour as the white paper. You don't want to leave any part of the paper completely white.

ALWAYS ROOM FOR IMPROVEMENT

8

Never think that your skills as an artist are complete. No matter how advanced an artist is, there's always room to learn and grow. Make a promise to yourself right now to never stop learning new skills and techniques. The world of art is big – there's always something new to discover.

ALWAYS REMEMBER THIS

9

For every mistake you make, you're getting closer to where you want to go. Any form of creativity is a learning process. Sometimes you have to take a step backward in order to take two forward.

TAKE A PAGE OUT OF SALVADOR DALI's SKETCHBOOK

He loved to break all the rules!

10

Tips to Remember

1 Don't overthink the drawing process
Stop thinking you are bad; draw purely for the act of drawing.

2 Look after your drawings!
Get a nice sketchbook, and a little folder so you can shove all your drawings in there, even scraps of paper.

3 Don't worry about having a style
Just embrace whatever comes naturally.

Say Hello to Saul Steinberg

'DRAWING IS A WAY OF REASONING ON PAPER.'

Cartoonist. Illustrator. Deep thinker. Romanian-born artist Saul Steinberg became revered as 'the writer who draws'. When Saul Steinberg put pencil to paper, the world paid attention.

Saul Steinberg — What Do We Know?

1 Born in 1914, Saul Steinberg was one of the most celebrated illustrators of the 20th century.

3 He is most recognised for his contributions to the prestigious *New Yorker* magazine, known internationally for its intelligent humour.

4 Steinberg's best-known work became perhaps too famous. He became known as 'the man who did that poster', a drawing titled *View of the World from 9th Avenue*.

6 Steinberg believed that everyone in society wears a mask, either a real one or a metaphorical one. He thought that we all invent and identify our personas through our clothing, hairstyles and behaviour, just like cities define themselves by their architecture, and nations by their icons and celebrities.

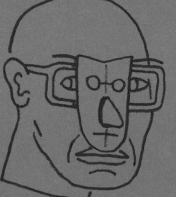

2 Saul Steinberg wasn't educated as an artist or illustrator. He originally trained as an architect, a school of thought that would later influence his work.

5 Steinberg's art cannot be confined to a single category or movement – he was a magpie, taking influences and themes from many different styles and working across all types of art media – collages, sculptures and drawings.

It may look like a simple drawing, but Steinberg's *Untitled* (1948), an ink sketch of himself as part of a large, single-line spiral, is technically brilliant. As the spiral moves downward, it metamorphoses into a left foot, then a right foot, then the profile of a body, until finally reaching the hand holding the pen that draws the line. This sketch of an artist drawing himself in one strong single line epitomises a fundamental principle of Saul Steinberg's work: his art is about the ways artists make art.

'YOU WON'T DRAW WELL IF YOU'RE TELLING A LIE. AND CONVERSELY, WHEN A DRAWING FROM LIFE TELLS THE TRUTH, IT AUTOMATICALLY TURNS OUT TO BE A GOOD DRAWING.'
Saul Steinberg

8 Steinberg stayed committed to drawing in an era when art became all about large-scale paintings and gaudy sculptures.

7 Steinberg believed that handwriting plays an important part in a drawing; he even invented his own unreadable calligraphy style — a parody of the fact that all official documents use the same type of overwrought calligraphy to impose a sense of authority.

9 Steinberg's first book was called *All in a Line* – effectively a copy of his sketchbook.

GOOD POINT!

In the 1960s, at the height of the space race, legend has it that NASA scientists realised that pens would not work in space. So, they set to work trying to figure out another way for the astronauts to write down their calculations. After spending millions of dollars, NASA failed to develop a pen that could write on paper in a zero-gravity atmosphere. The Soviet astronauts, so the story goes, simply used pencils. However, this famous anecdote is actually just a myth.

Whose Line Is It Anyway? #2

Here are more gems from some of the world's greatest pencil-wielders from past and present.

'ALL GOOD AND GENUINE DRAUGHTSMEN DRAW ACCORDING TO THE PICTURE INSCRIBED IN THEIR MINDS, AND NOT ACCORDING TO NATURE.'

Charles Baudelaire

'YOU CAN'T DO SKETCHES ENOUGH. SKETCH EVERYTHING AND KEEP YOUR CURIOSITY FRESH.'

John Singer Sargent

'THE VERY ACT OF DRAWING AN OBJECT, HOWEVER BADLY, SWIFTLY TAKES THE DRAWER FROM A WOOLLY SENSE OF WHAT THE OBJECT LOOKS LIKE TO A PRECISE AWARENESS OF ITS COMPONENT PARTS AND PARTICULARITIES.'

Alain de Botton

'DRAWING IS RATHER LIKE PLAYING CHESS: YOUR MIND RACES AHEAD OF THE MOVES THAT YOU EVENTUALLY MAKE.'

David Hockney

'DRAWING IS THE HONESTY OF THE ART. THERE IS NO POSSIBILITY OF CHEATING. IT IS EITHER GOOD OR BAD.'

Salvador Dalí

'DRAWING IS NOT WHAT ONE SEES BUT WHAT ONE CAN MAKE OTHERS SEE.'

Edgar Degas

'YOU CAN NEVER DO TOO MUCH DRAWING.'

Jacopo Tintoretto

'DO NOT FAIL, AS YOU GO ON, TO DRAW SOMETHING EVERY DAY, FOR NO MATTER HOW LITTLE IT IS, IT WILL BE WELL WORTHWHILE, AND IT WILL DO YOU A WORLD OF GOOD.'

Cennino Cennini

'DRAWING IS TAKING A LINE FOR A WALK.'

Paul Klee

'TO ERR IS HUMAN, BUT WHEN THE ERASER WEARS OUT AHEAD OF THE PENCIL, YOU'RE OVERDOING IT.'

Josh Jenkins

'I SOMETIMES THINK THERE IS NOTHING SO DELIGHTFUL AS DRAWING.'

Vincent Van Gogh

'DRAW, ANTONIO, DRAW — DRAW AND DON'T WASTE TIME!'

Michelangelo

'IT IS ONLY BY DRAWING OFTEN, DRAWING EVERYTHING, DRAWING INCESSANTLY, THAT ONE FINE DAY YOU DISCOVER TO YOUR SURPRISE THAT YOU HAVE RENDERED SOMETHING IN ITS TRUE CHARACTER.'

Camille Pisarro

'TO DRAW, YOU MUST CLOSE YOUR EYES AND SING.'

Pablo Picasso

'ONE MUST ALWAYS DRAW, DRAW WITH THE EYES, WHEN ONE CANNOT DRAW WITH A PENCIL.'

Balthus

'PHOTOGRAPHY IS AN IMMEDIATE REACTION, DRAWING IS A MEDITATION.'

Henri Cartier-Bresson

'ART, LIKE MORALITY, CONSISTS IN DRAWING THE LINE SOMEWHERE.'

G. K. Chesterton

How to Draw a Car

The Race Is On!

Driving an awesome supercar may be one of life's greatest pleasures. Drawing one is even better, though! But before we go from 0—120 in 0.6 seconds, let's slow down, apply the brakes and get our heads around the basic principles of how to draw a car that not only looks cool, but real too.

Let's make this exercise a bit more interesting. Give yourself ten minutes to draw three types of car – a classic vintage car, a modern supercar, and a car that no one has ever seen before – something truly unique, like a flying car-tank hybrid!

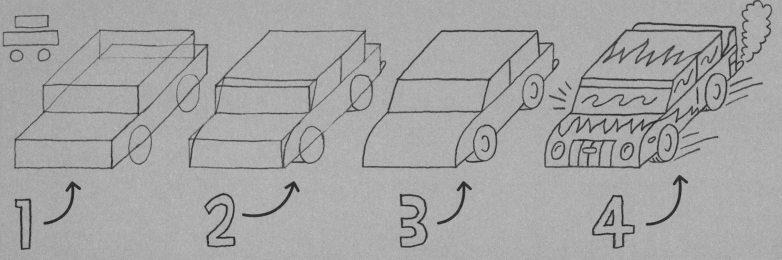

1 Remember how to draw 3D shapes (see page 32)? First things first, we need to stack a short rectangle on top of a large one, like so... Draw each rectangle separately as you would any 3D object. In this example, the car is drawn from a tilted perspective, not a full-on front view or straight side profile. Draw two wheels for positioning.

2 Curve the edges of the car's sharp angles if you want to give your car that modern supercar feel. If not, retain the sharp angles for an old-car feel!

3 Finesse your drawing. Remove initial sketch lines and bulk up the outline of the car, leaving a definitive car shape. Notice how the windscreen is slanted to give an extra dimension to the car's appearance.

4 Add the detail – go-faster stripes, logos, spoilers, movement lines – whatever you want!

Movement lines are a great device to add to your drawing to signify speed, or a lack thereof.

MAKE A PAPER PLANE

This paper plane is no ordinary paper plane. Not only is it going to fly perfectly, but we're also going to use our pencils to decorate it, so that it stands out from the others.

1 Grab a piece of A4 paper.

2 Fold it in half.

3 Tuck down the top right-hand corner to meet the centre fold.

4 Repeat for the left-hand side.

5 Repeat step 3, but make sure the tuck reaches all the way down to the bottom edge of the piece of paper. Repeat for the left-hand side. Make sure the creases in the paper are firm.

6 Fold the wings back – and now you have a flying plane.

7 Grab your trusty pencil and scribble a logo on the plane as if it were your own airline!

Hyperrealism artist Stefan Pabst's stunning 3-D illusion art and photorealistic portraits seem to completely defy physics — especially in the way he uses perspective and shading to make things jump off the page! Pabst uses a range of pencil technique for his 3-D drawings, though it is the the *trompe l'oeil* technique (a French term literally meaning 'trick the eye') that has made him a YouTube celebrity. Pabst's painting of a glass of water — which he captured on video and uploaded to his YouTube channel — is unbelievable. Make sure you check it out.

GOOD POINT!

How to Draw a Bike

Drawing a bike is a lot like riding a bike. Once you learn how to do it, you never forget! You might think that a simple bike sketch would just consist of two circles and a few connecting lines, and you're right, but if you want your beginner's bike sketch to really stand out, just follow these effective steps.

On Your Bike!

There are many ways to draw several types of bikes, i.e. cartoon, technical or hyperrealistic. Technically speaking, a bike is made out of 'tubes' (ask any bike mechanic), forks and wheels. As always, we'll stick to the basics, but feel free to embellish as you go along.

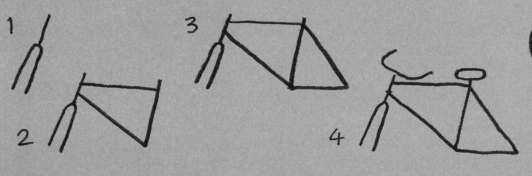

1 Lightly at first, for your initial sketch draw the front fork and head tube (the bit that connects the fork to the handlebars), as it is known. Remember, give yourself plenty of space on the page and don't draw this first step too close to the centre of the page. Keep left!

2 The top tube, down tube and seat tube follow. These should form an isosceles triangle shape, but with no tip.

3 Add the 'seat stay' and 'chain stay' parts of the bike. Again, these should form a right-angled triangle.

4 Now add the handlebars and seat.

5 Two big wheels come next. Sketch light circles or use a compass to make them nice and tidy. Or refer to How to Draw a Perfect Circle, page 86.

6 Go back over your sketch lines with a thicker line and add in texture and detail. You can include spokes, but be careful, as these can make the sketch look messy if not straight.

'EVERY TIME I SEE AN ADULT ON A BICYCLE, I NO LONGER DESPAIR FOR THE FUTURE OF THE HUMAN RACE.'

H. G. Wells

GOOD POINT!

Bicycles are works of art in themselves. They have long inspired artists too — a natural extension of the legs. Salvador Dalí's *Bicycle Man* (1977) is a wonderful example of a minimal pencil sketch that the artist drew quickly but which expertly displays perspective, the artist's revered sense of surrealism, and a landscape that intrigues the eye.

Have a go at drawing a bike in your favourite art style.

Charlie Charlie

Sometimes known as Charlie Pencil, the Charlie Charlie challenge is a favourite game among pencilmaniacs (also known as pencilholics) who like the darker side of life. The game is similar to using an ouija board, and is great fun to play for those who get spooked easily. Don't miss out, but be warned, it could get a bit scary!

ARE YOU REAL?

Ask the Demon

1 On a sheet of paper, draw a vertical and horizontal line to make a cross. Put a 'yes' in the top-right and bottom left-hand corners of the paper, and a 'no' in the remaining two.

2 Now, lay a pencil right on the horizontal line. Balance another pencil on top of that, along the vertical line.

3 To properly summon the demon, you now have to say out loud, 'Charlie, Charlie, can we play?'

4 Watch. The pencils should start moving. If they go to 'yes', the evil spirit is ready and willing to answer your questions. Put the pencil back, and use the same technique to get answers. If it's a 'no', you'll have to play again later when Charlie is in a better mood.

5 Remember, if you want to stop the game, chant the important words 'Charlie, Charlie, can we stop?' and say goodbye when the demon says yes. If he says no, you have to keep playing, otherwise... bad things will happen.

YES

NO

NO

YES

HOW DOES IT WORK?

Gravity, mainly. The awkward positioning of the pencils on top of each other means that even if you don't want them to, the pencils will move!

⬇

WHY DOES SCARY STUFF HAPPEN AFTERWARDS?

WHO IS CHARLIE?

⬇

As with most urban legends, the story of Charlie the demon depends on which version you've heard. Many claim Charlie is a little boy who took his own life, while others say he is a demonic Mexican man with black and red eyes! The only way to find out who he is for sure is to play the game and ask him!

The Scribble Game

A classic drawing game and a great way to turn your scribbles into drawings and then into works of art. Ideal for filling your sketchbook with loads of fun ideas that could easily turn into mini masterpieces!

1 Every player should scribble something quickly on their sheet of paper.

2 Swap scribbles with the other players.

3 Look at the scribble in front of you to see what the lines suggest or remind you of (you may want to turn it upside down or sideways).

4 Finish the drawing by adding your own lines and marks, turning the scribble into the thing it reminds you of.

ssss...

Pencil Facts #3

In 1779, chemist K. W. Scheele made a chemical analysis of 'plumbago' (the carbon that people first thought was lead) and proved it to be a form of carbon, not of lead. In 1789, another chemist called A. G. Werner suggested that the 'lead' in pencils be renamed 'graphite', from the Greek for 'to write'.

One tree makes approximately 170,000 pencils.

The German pencil manufacturer Faber-Castell, the oldest pencil-making company in the world, makes approximately 1.8 billion pencils per year.

The smallest pencil in the world measures 17.5mm long, is about 5mm wide and contains a 3mm graphite lead. It was made by Faber-Castell as a limited-edition pencil. It can write, but you'd need a pair of tweezers!

The Graf von Faber-Castell Perfect Pencil (limited edition) is the world's most expensive pencil. It is made with white gold and diamonds and costs around £150. A typical 2B pencil costs 7 pence!

The world's oldest surviving pencil was found in the loft of a German house and dates back to the 17th century. It is now part of the Faber-Castell private collection.

The revered American author John Steinbeck is said to have used more than 300 pencils to write his masterpiece, *East of Eden*: 'I have owed you this letter for a very long time — but my fingers have avoided the pencil as though it were an old and poisoned tool.'

GOOD POINT!

Have you ever wondered why pencils are often painted yellow? It isn't so you can find them in the dark! During the 1800s, the best graphite in the world came from China. American pencil-makers wanted a special way to tell people that their pencils contained Chinese graphite. In China, the colour yellow is associated with royalty and respect. American pencil manufacturers began painting their pencils bright yellow to communicate this 'regal' feeling and association with China. Today, 75 per cent of the pencils sold in the United States are painted yellow.

Toilet Wall Doodles

Let's face it, we've all been in a public toilet cubicle minding our own business and then happened to glance at the door or wall and seen a funny doodle. Immediately, we all think, 'Damn, I wish I had thought of that... ' Well, now you can.

FLUSH

U STINK

LET GO

Say Hello to Dr Seuss

Hands up if you've heard of Dr Seuss! One of America's most famous children's authors and illustrators, Theodor Seuss Giesel ('Seuss' was also his mother's maiden name) has sold more than 600 million books and his pen-and-ink style of drawing influenced generations of aspiring artists.

Dr Seuss — What Do We Know?

1 Dr Seuss (1904–1991) was not a doctor... of anything! He added the 'Dr' to his pen name because his father had always wanted him to become a doctor.

2 The correct pronunciation of 'Seuss' is supposed to rhyme with 'voice' rather than 'goose,' but the writer eventually gave in to the popular pronunciation.

3 Dr Seuss invented the word 'nerd', mentioned in the *If I Ran the Zoo* story, which was published in 1950.

4 Dr Seuss may be 'just' a silly author to kids, but he also won a Pulitzer prize and two Academy Awards. He won his first Oscar for writing an animated short film called *Gerald McBoing-Boing* in 1951.

5 In 1960, Seuss's editor bet Seuss he couldn't write a book using only 50 words. Seuss won. The result? One of the most popular stories ever written – *Green Eggs and Ham*, which uses exactly 50 words. They are: 'I am Sam; that; do not like; you green eggs and ham; them; would here or there; anywhere; in a house with mouse; eat box fox; car they; could; may will see tree; let me be; train on; say the dark; rain; goat; boat; so try may; if; good; thank. We could not say that five times fast. Would not, could not.'

6 Seuss's books are renowned for clever rhymes, plot twists and rebellious heroes who end up doing the unexpected.

'YOU HAVE BRAINS IN YOUR HEAD. YOU HAVE FEET IN YOUR SHOES. YOU CAN STEER YOURSELF ANY DIRECTION YOU CHOOSE.'

7 *The Cat in the Hat*, published in 1957, is Seuss's most famous story. He was asked to produce the book with 220 words in it that would expand children's vocabularies.

8 Seuss was this_____ close to burning the only manuscript of his first book, *And to Think that I Saw it on Mulberry Street*, after it was turned down by 27 publishers, before it was finally published in 1937.

10 Seuss's surreal and zany illustrations and rhymes have lived for generations because they allow the reader to enjoy the heavily moralistic stories (either a fable, fairy tale or outlandish adventure) within them without being preached to.

9 All his characters look the same – Dr Seuss only ever really drew one human face!

How to Draw a Still Life

Understanding the techniques for drawing still lifes teaches us how to look at ordinary objects, such as a fruit bowl or a can of soup, and view them as an artist would.

GOOD POINT!

Some of the most famous still-life paintings in the world have been of flowers, fruit and fruit bowls. Notable still-life painters such as Claude Monet, Vincent Van Gogh and Paul Cézanne have created flowery and fruity masterpieces, such as Van Gogh's *Vase with Fifteen Sunflowers* and Cézanne's *Basket of Apples*. These paintings depict more than just a boring bowl of fruit. Instead, they delve into the finer details of how we see these objects by exploring light, shadow, tone and composition.

'TREAT NATURE BY THE CYLINDER, THE SPHERE AND THE CONE.'

Paul Cézanne

How to Draw Fruit Like Cézanne

1

Think about which object, or set of still-life objects, you want to draw. Perhaps draw the contents of a kitchen drawer, a collection of ornaments found on the mantelpiece, or a picture frame with a photograph of your family in it. Think about the arrangement of the objects on the table and the pattern or shadows that the arrangement creates.

2

In any still-life drawing, you should always reduce the objects to their simplest forms. An apple is a circle, a box is a cube, a stick is a cylinder. This technique helps you understand the shape of each individual item and its position in relation to other objects. Sketch the objects lightly at this stage.

3

Once you are happy with the shape, proportion and composition of your still life, erase your sketch lines. A visible outline of each object will remain.

4

You are now ready to work on the details of each object. Lightly sketch in the shapes any shadows, reflections or patterns. If it helps, lightly sketch the outline of a grid.

5

Pay attention to the light source and the shape of the shadows.

How to Draw Pizzas and Mandalas

The whole world has gone bonkers for mandalas recently, so we thought it best to include one here too. They look like intricate pizzas to us, so we thought we'd educate you about how to draw pizzas, too.

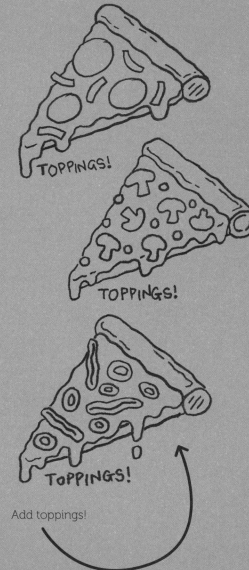

TOPPINGS!

TOPPINGS!

TOPPINGS!

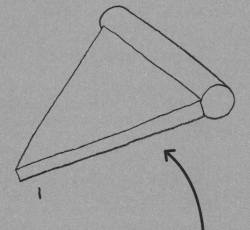

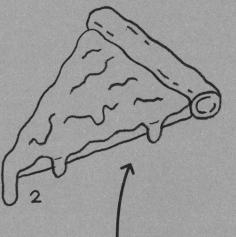

Pizza!

Draw – lightly – an isosceles triangle. For a 3D effect, add a base. Attach a crust – a cylinder shape affixed to the shortest end of the triangle.

Add melted cheese, as shown. For the best effect, have the cheese melting over the edge of the base. Once you are happy with the cheese, darken the lines with a thicker pencil or push harder on the page.

Add toppings!

Mandala!

1 Draw a large circle (see page 86 for how to do this freehand). Divide the circle into pizza slices.

2 In each 'slice' draw the same shapes, so that they are mirrored in every slice. In this example, we've drawn circles – but feel free to add whatever you wish – just make sure it is duplicated in every slice.

3 Add more shapes. Remember to duplicate them in every slice.

GOOD POINT!

What is a mandala, I hear you ask. Good question. It is a spiritual symbol in Indian religions and represents the universe and the cosmos, metaphysically and symbolically. Within the circle, all of life is contained. In modern usage, a mandala has become a generic term for a pretty geometric pattern contained within a circle.

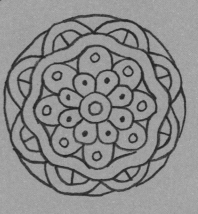

4 Erase the sketch lines *et voilà* – a mandala!

5 Colour in as desired.

Say Hello to Jack Kirby

'EVERYBODY CAN DRAW, IN MY ESTIMATION.
IF YOU GIVE A MAN 50 YEARS, HE'LL COME
UP WITH THE *MONA LISA*'

Jack Kirby

It might be the name of Marvel Comics' Stan Lee that you see and hear the most these days, but it is Jack Kirby, the creator of many of the world's most famous comic book characters, whose superhero stories have defined the 21st century. He is the father of superheroes, the 'King of comics', the granddaddy of 'With great power comes great responsibility...'

What Do We Know?

Kirby is renowned as one of the most prolific artists of the 20th century, with a career that spanned 45 years. Many of the characters Kirby created were based on himself, most famously the huge, rock-shaped humanoid object from the *Fantastic Four*, The Thing.

How to Draw Your Own Superhero

Practise this quick, five-minute exercise every day until you get a drawing that you're really happy with. Each day, do something different – for example feel free to try it with animals (SuperDog!) and inanimate objects (SuperPencil!).

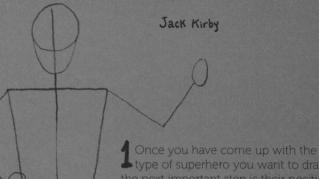

1 Once you have come up with the type of superhero you want to draw, the next important step is their position on the page. Are they standing tall? Are they having a rest? Are they throwing a punch or holding their nemesis by the jugular? Rough out the outline of your superhero's position with the basic shapes – an oval, as always, for the head, connected to a tapered rectangle for the torso. Lines will do for arms at this stage.

2 Superheroes (at least the super-strong ones) are all about muscle definition. Once you've sketched a wire frame for the body, begin adding muscles. Famously, Superman was also drawn with extra-broad shoulders and a tiny waist and then thick legs. Where is your superhero the most muscley?